Raptors

in the Wild

A Visual Essay of Hawks, Eagles, Falcons, and more

Rob Palmer

AMHERST MEDIA, INC. ■ BUFFALO, NY

Published by:
Amherst Media, Inc., P.O. Box 538, Buffalo, N.Y. 14213
www.AmherstMedia.com

Publisher: Craig Alesse
Senior Editor/Production Manager: Michelle Perkins
Editors: Barbara A. Lynch-Johnt, Beth Alesse
Acquisitions Editor: Harvey Goldstein
Associate Publisher: Katie Kiss
Editorial Assistance from: Carey A. Miller, Rebecca Rudell, Jen Sexton-Riley
Business Manager: Sarah Loder
Marketing Associate: Tonya Flickinger

ISBN-13: 978-1-68203-326-3
Library of Congress Control Number: 2018936004
Printed in The United States of America.
10 9 8 7 6 5 4 3 2 1

www.facebook.com/AmherstMediaInc
www.youtube.com/AmherstMedia
www.twitter.com/AmherstMedia

AUTHOR A BOOK WITH AMHERST MEDIA!

Are you an accomplished photographer with devoted fans? Consider authoring a book with us and share your quality images and wisdom with your fans. It's a great way to build your business and brand through a high-quality, full-color printed book sold worldwide. Our experienced team makes it easy and rewarding for each book sold—no cost to you. E-mail **submissions@amherstmedia.com** today!

Contents

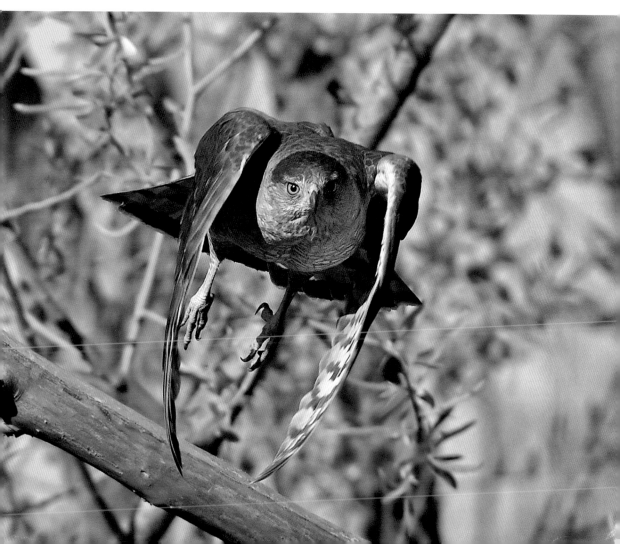

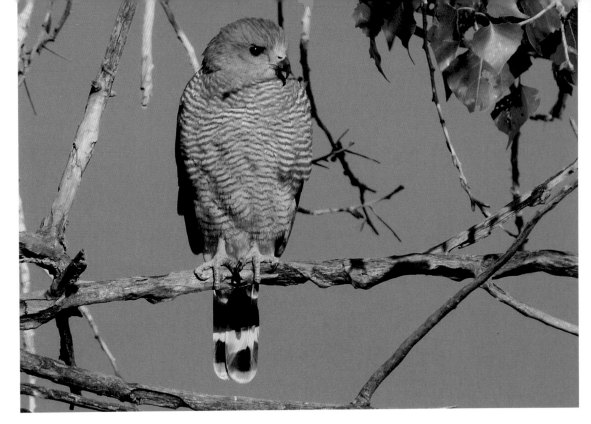

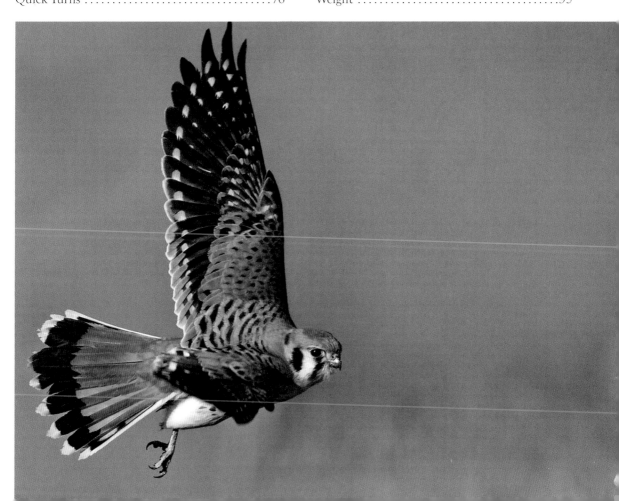

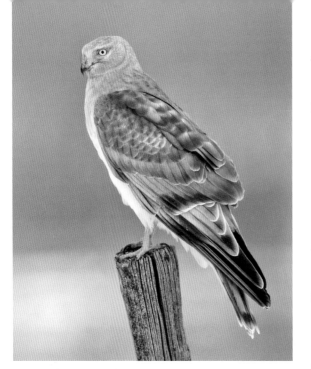

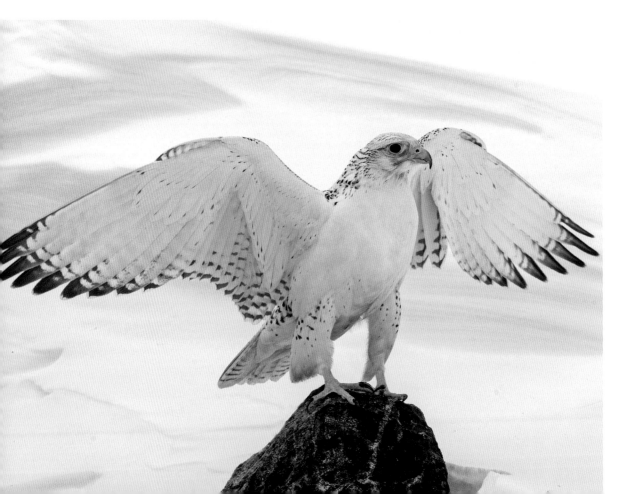

About the Author

Naturalist

Rob Palmer has been involved with animals since he was very young. He has always had a passion for birds of prey, and has pursued that passion throughout his adult life. In college, he spent numerous hours studying the nesting territories of prairie falcons in Northeastern Colorado and additional time researching owls nesting along the Boulder Creek trail in the center of Boulder, Colorado.

Photographer

Rob began taking pictures with a Polaroid black & white camera when he was twelve, then quickly moved on to a 35mm SLR. His first SLR was a Kowa. In high school, he became the school's photographer and was able to use the school's Pentax cameras. The basics in photography have stuck with him.

Teacher

Rob has also been a teacher all his life. He taught secondary school biology for ten years and outdoor education over the years. He now teaches photography both outdoors and inside the classroom.

Awards & Publication

2005: *Mating Avocets.* Winner, Birds Category, *National Wildlife Magazine,* back cover.

2005: *Goldeneye and Ducklings.* Winner, Birds Category, *Wild Bird Magazine.*

2006: *Swift Fox with Kangaroo Rat.* Winner, Animal Behavior, *National Wildlife Magazine.*

2007: *Pronghorn Jumping.* Grand Prize Winner, Wildlife Photographer of the Year, *National Wildlife Magazine.*

2007/2008: *Hovering Kestrel.* Winner, Birds Category, *National Wildlife Magazine.*

2008: *Battling Eagles.* Image of the Year, Photographic Society of America.

2009: *Eagle and Blackbird.* BBC Wildlife Photographer of the Year Winner, Bird Behavior Category.

2009: *Eagle and Starling.* Winner, Birds Category, *National Wildlife Magazine.*

2011: *Burrowing Owlets and Prairie Chickens. Nature's Best Magazine* Highly Honored Images.

2011: *Battling Eagles.* Grand Prize, *Audubon Magazine* front cover.

2012: *Dancing Prairie Dog. Nature's Best Magazine* Highly Honored image.

2013: *Preening Kestrel. Nature's Best Magazine,* Highly Honored image, Art in Nature Category.

2013: *Nature's Best Magazine,* Vole and Coyote 3rd Place professional.

Rob's images have also been featured on the covers of *Birder's World, Living Bird, American Falconry,* and *National Wildlife.*

Contact

http://www.falconphotos.com

1. Woodland Hawks

In North America, the woodland hawks are comprised of three species: the sharp-shinned hawk, the Cooper's hawk, and the goshawk.

They are very quick hawks with short wings and long tails for maneuverability so they can chase their quarry through woods and thick cover.

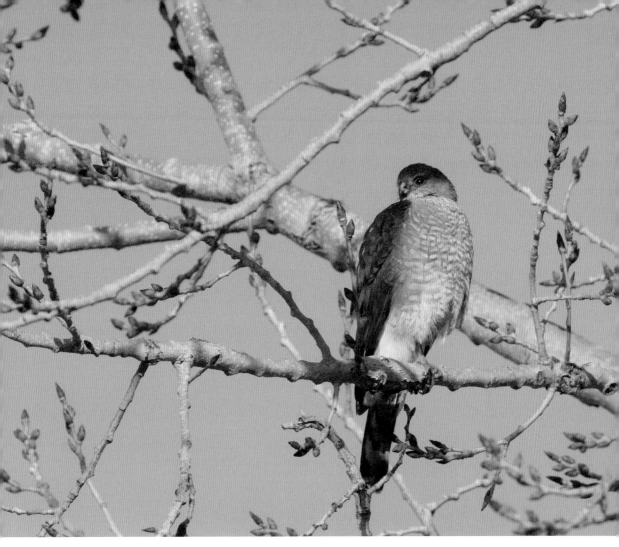

Sharp-Shinned Hawks

above—Sharp-shinned hawks are the smallest of the woodland hawks. Although not much bigger than a robin, they are menaces to small birds everywhere. They are primarily bird eaters, hunting sparrows and other similar birds.

right—Most of the time you can see them sitting on a branch in a tree, waiting for an opportunity to chase their quarry. The pursuit usually lasts no longer than a few seconds.

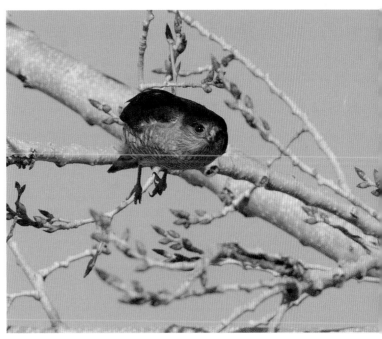

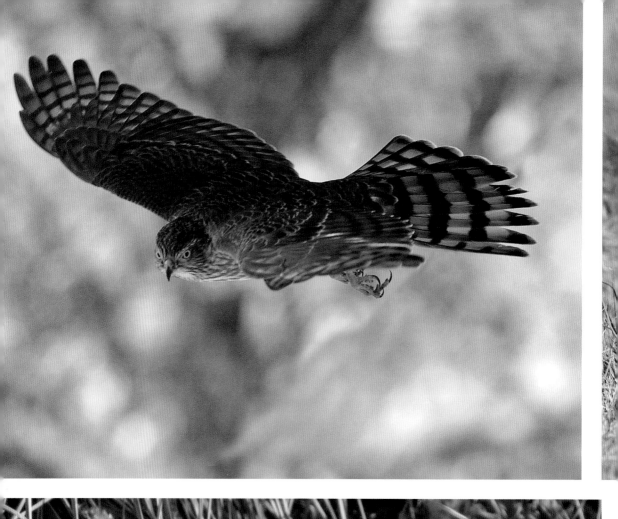
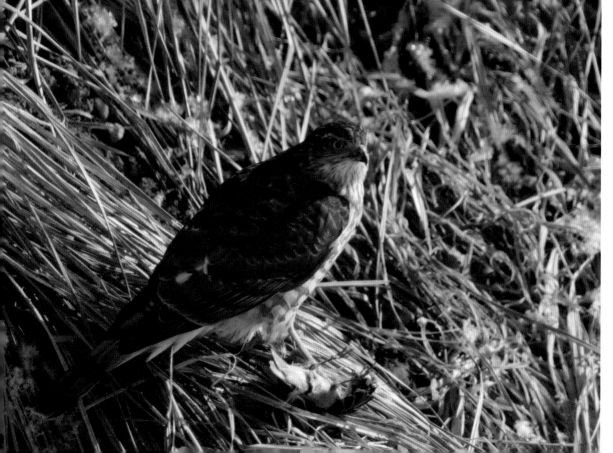

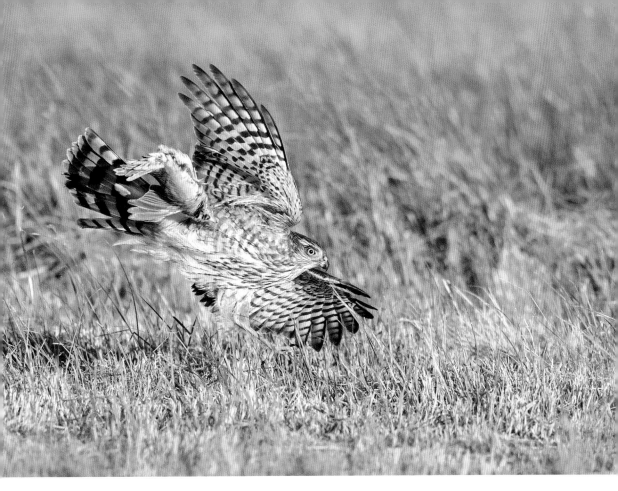

Fresh Catch

above—A sharp-shinned hawk just after catching a house sparrow on the ground. *Photo by Angela McCain.*

Juveniles

facing page, top—This juvenile sharp-shinned hawk was chasing birds near a feeder in my backyard. I took the photo through a window.

facing page, bottom—Here's another juvenile who has caught a sparrow.

Cooper's Hawks

Cooper's hawks are medium-sized birds, a little bigger than a pigeon. The adults have either orange or red eyes that are very captivating. They are very similar to sharp-shinned hawks, but larger and with rounded tails (instead of square tails), as well as a few other distinguishing characteristics.

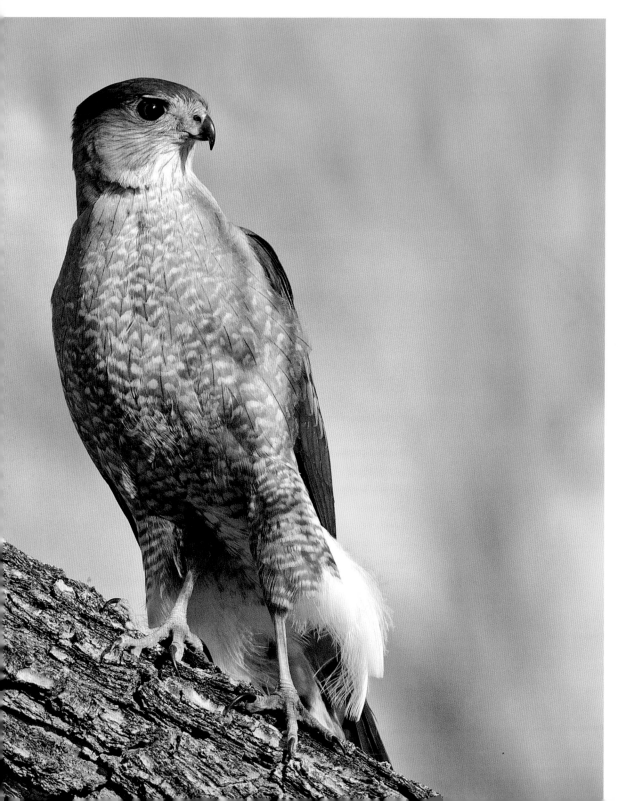

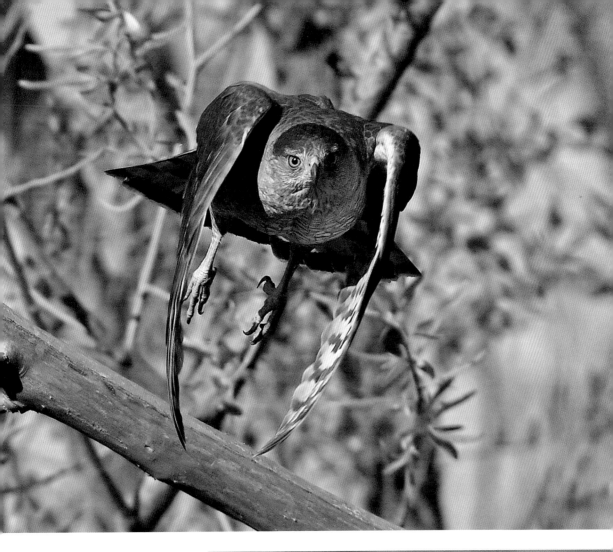

Nesting

above—In spring, Cooper's hawks can be found in deciduous forests throughout North America. They are also common in many cities. This one was not too happy when I came a bit too close to her nest. She veered off at the last second and I was spared her wrath.

right—An adult male is busy bringing branches from a cottonwood tree to build his stick nest high in a cottonwood.

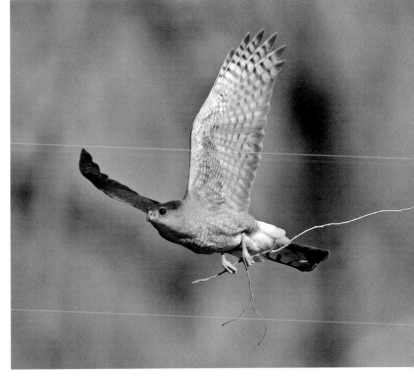

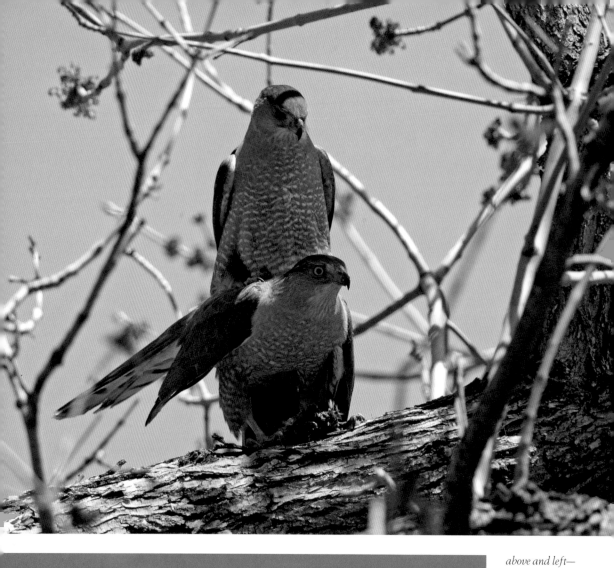

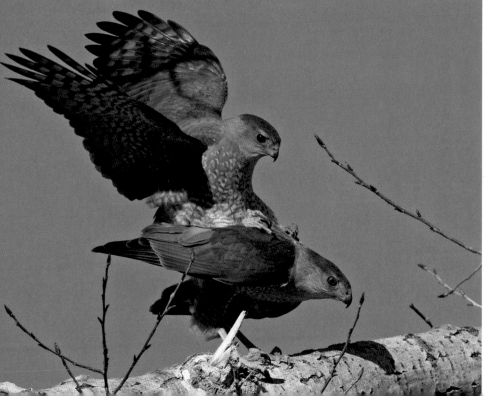

above and left—
Courtship begins in earnest in early spring with mating occurring many times a day. Often, the male will bring in tasty morsel to keep the female occupied while they mate.

below—One day in the spring, I was near a nesting territory when I found this female Cooper's hawk eating a small bird. Suddenly, a mallard duck happened by. Cooper's hawks have been known to catch ducks, but this one did not seem worried in the least.

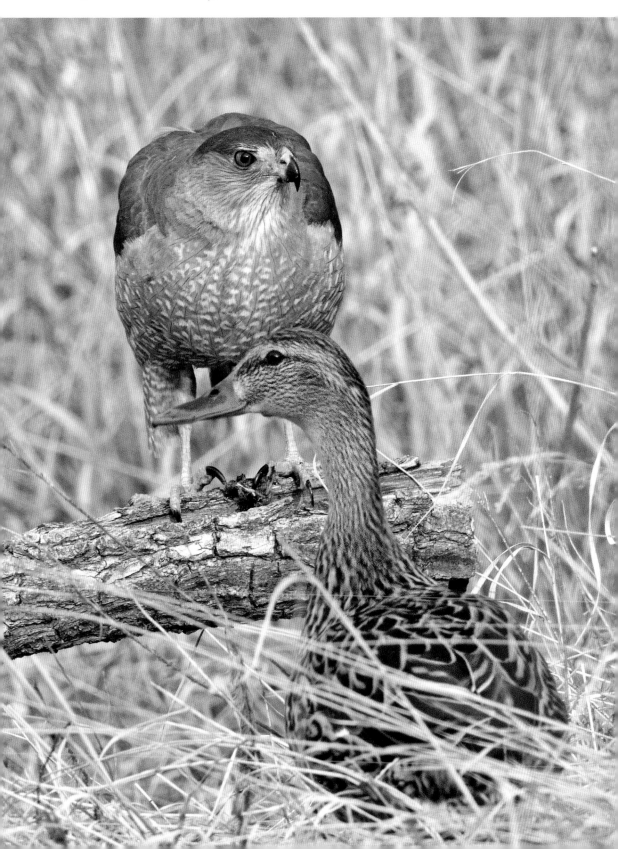

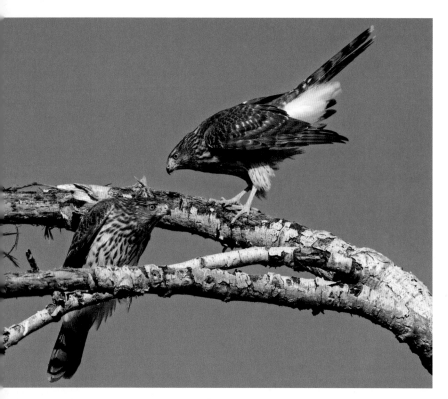

A Mock Battle

left and below—This pair of juvenile hawks had fledged a couple weeks earlier. They chased each other around the forest, engaging in mock battle— but no one was harmed.

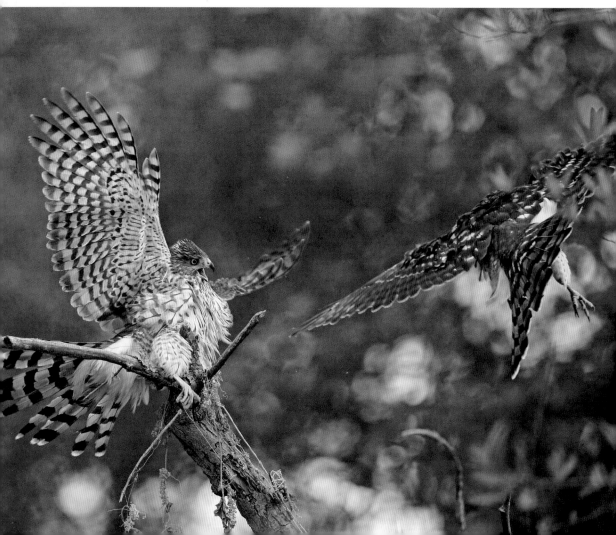

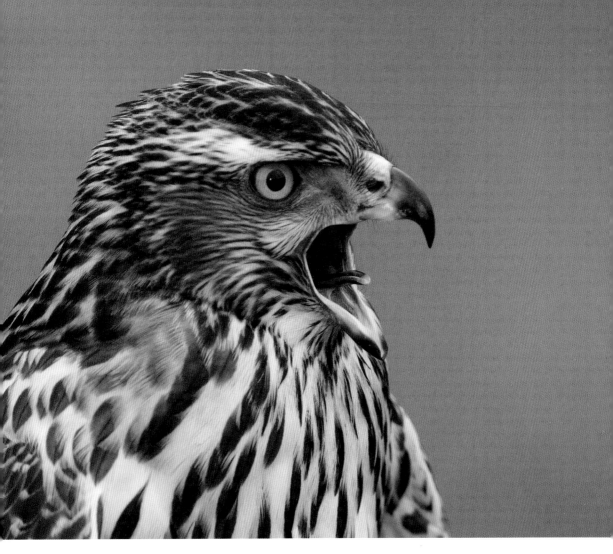

Goshawks

above—Goshawks are the largest of the woodland hawks, ranging from about the size of an American crow to that of a chicken. They are the birds that farmers call "chicken hawks," because they are the only hawks that will habitually kill chickens. They are birds of the woods and also very secretive. This one is a juvenile (first year bird).

right—This is an adult goshawk. If you do happen upon a nest in a tall tree, beware! Goshawks are known to attack passers-by if they get too close.

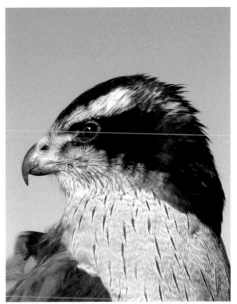

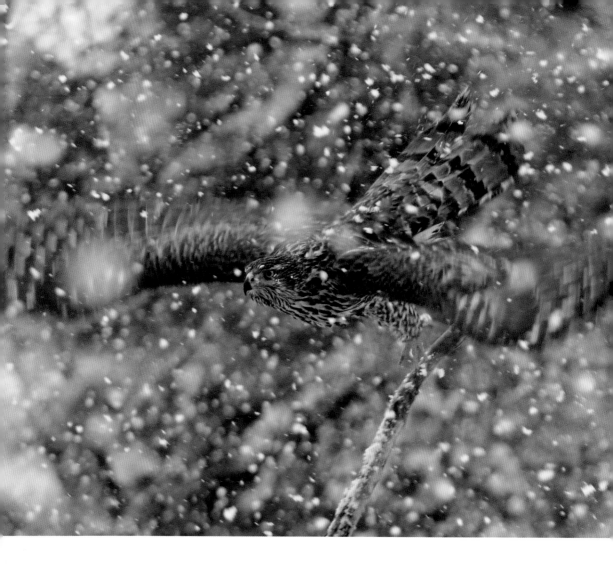

Cold Outside

above—An immature goshawk flying in a snow-storm. Cold weather is not a problem for this northern species.

Nesting

facing page, top—This is a typical goshawk nest with the female attending. The nests are usually found in a tall deciduous trees, like aspens or cottonwoods.

facing page, bottom—Here, the female is announcing her disapproval of my presence. If I were to get too close, she would let me know.

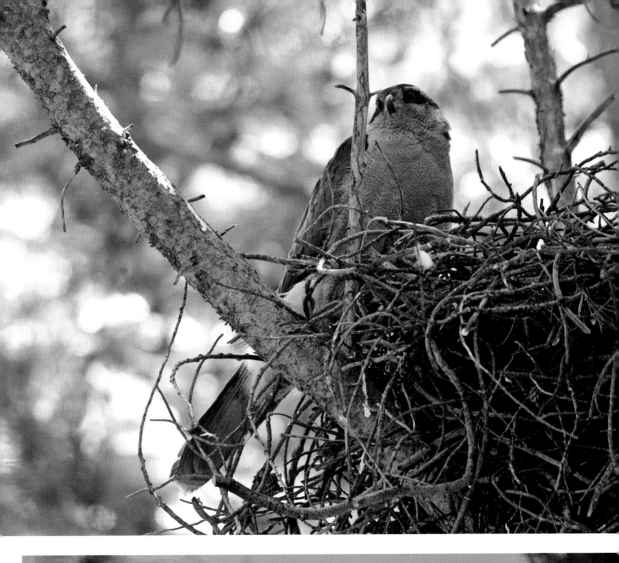
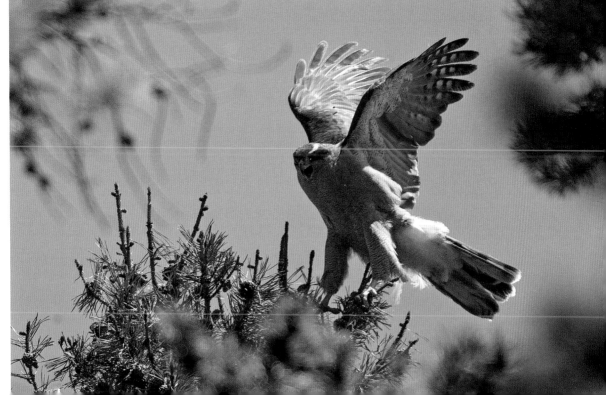

2. Buteos

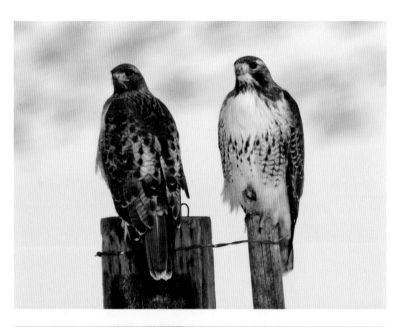

Red-Tailed Hawks

top left—The most common of all the buteos is the red-tailed hawk. From this photo, you can see why they are called this. This photo also shows the difference in size between the male on the left and the female. The female, in almost all raptors, is approximately one-third larger.

bottom left—Red-tailed hawks can be found sitting together as a mated pair almost any time of year. They typically mate for life and their lifespan can be as much as thirty years.

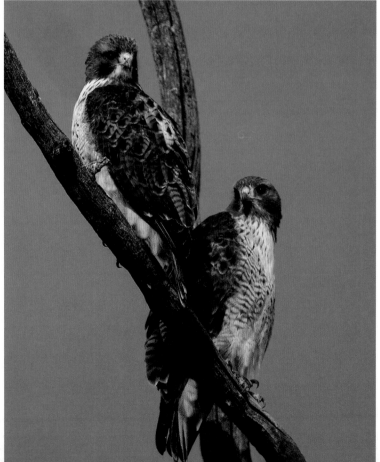

Intensity

facing page, top and bottom—A hunting red-tail is very intense. You can see how she focuses very sharply on her prey.

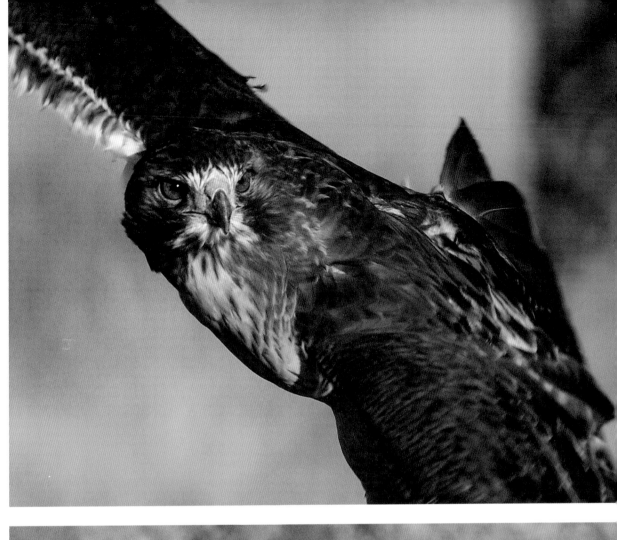
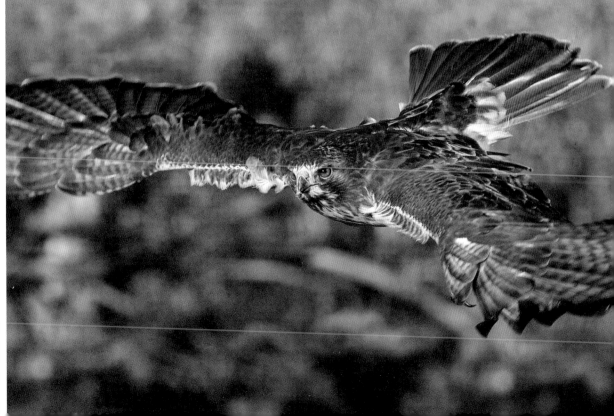

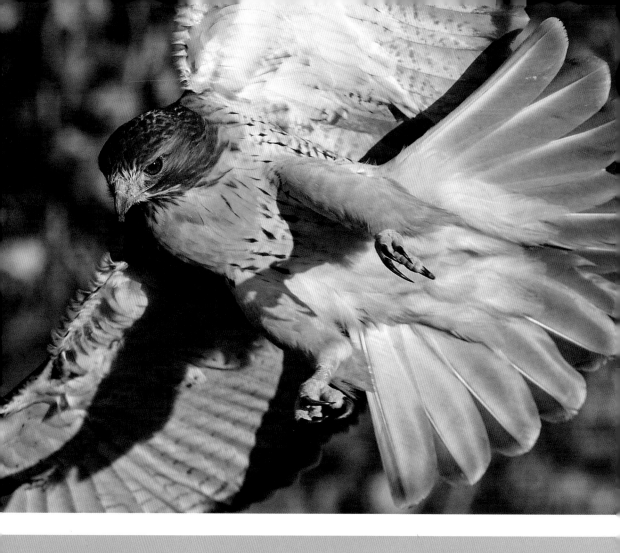
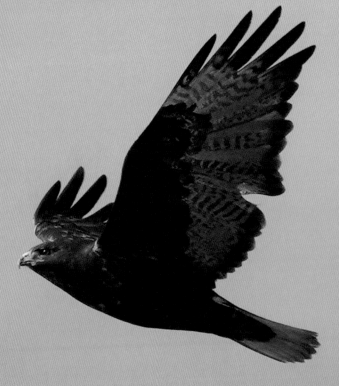

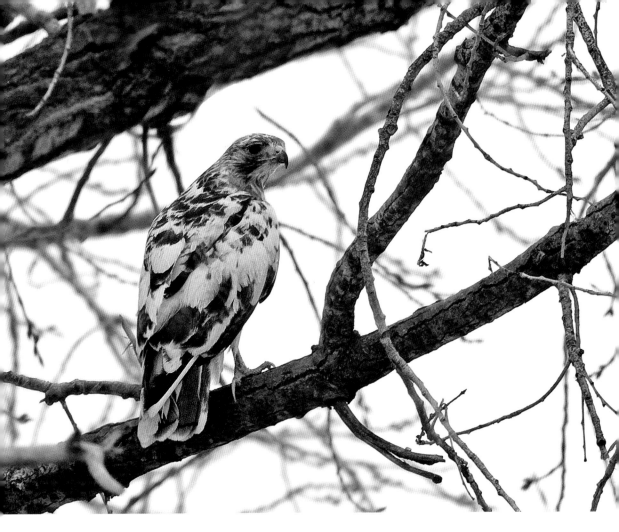

Varied Coloration

facing page, top—Redtails come in various color phases, from the typical red-tail seen here, to almost all black, and almost all white.

facing page, bottom—This almost all black hawk is called a Harlan's red-tail.

above—This red-tail is very uncommon. I like to call it a pied red-tail. This is a genetic anomaly called partial leucism or partial albinism.

right—This red-tail is almost totally white, but it's still another version of partial leucism. There is a very good chance that this hawk and the one above are related; they were found within twenty miles of each other.

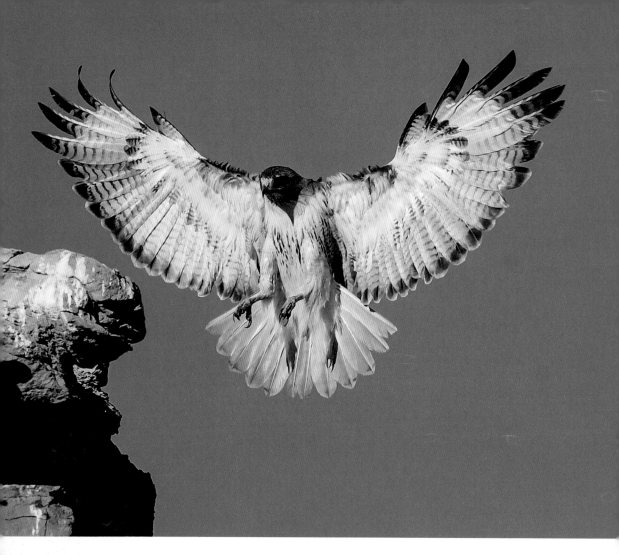

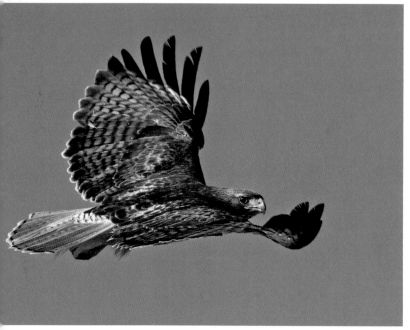

Nesting and Hunting

above—In the western half of North America, red-tails commonly build their stick nests on the sides of cliffs. In the east and many other locations, they tend to build their nests in tall trees.

left—It's common to see red-tails soaring high above, searching out thermal air pockets as they search for a meal. Their prey can range from mice and other rodents to rabbits and other larger mammals.

right—A red-tail is being escorted out of the nesting territory of a northern harrier. The harrier did not want marauding hawks anywhere near the nest.

below—This red-tail is about to catch a cottontail rabbit—or so he thinks. The rabbit made a quick turn and the red-tail missed his target.

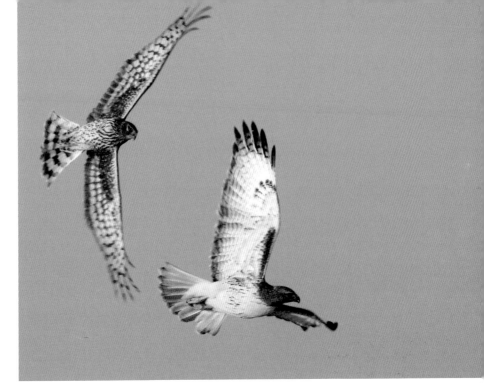

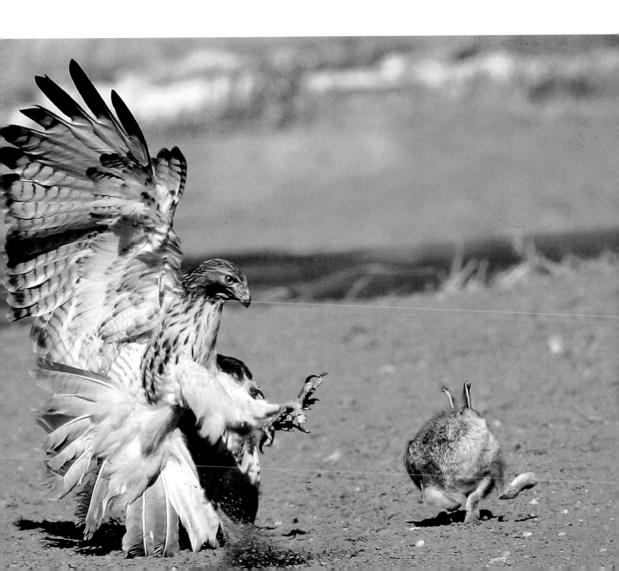

Swainson's Hawks

below—A common bird of the Great Basin and Central Plains is the Swainson's hawk. They are only in North America during the spring and summer; they spend the winters in South America. This one is a beautiful immature bird.

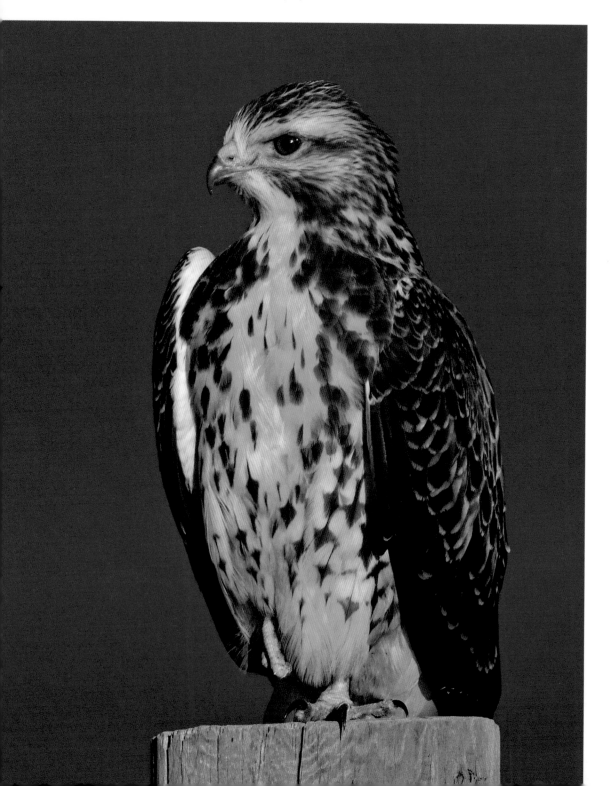

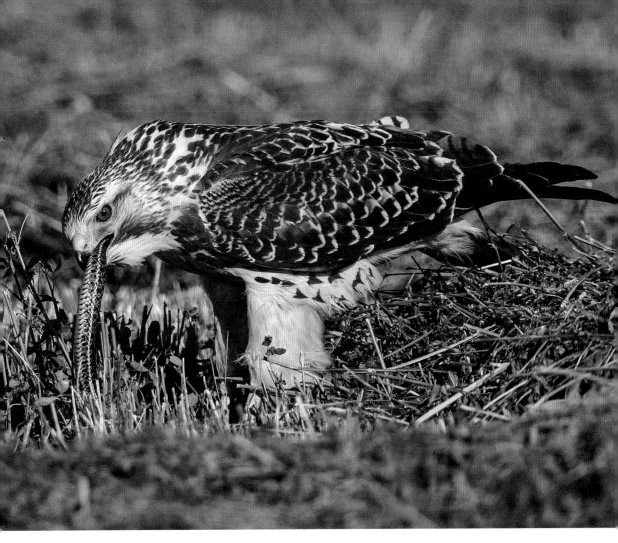

Hawk vs. Garter Snake

above—This garter snake looks like it might be too big for the young Swainson's hawk to handle, but she had no problem with it.

right—Here she is flying away with the snake and giving me a nice look back.

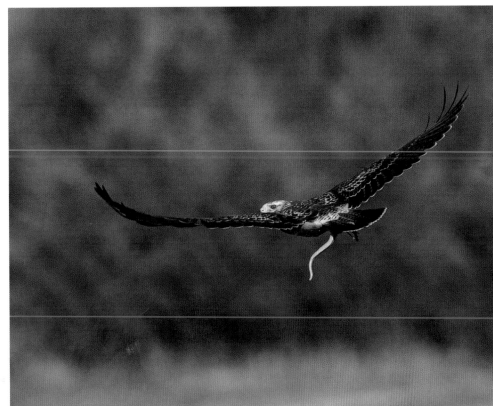

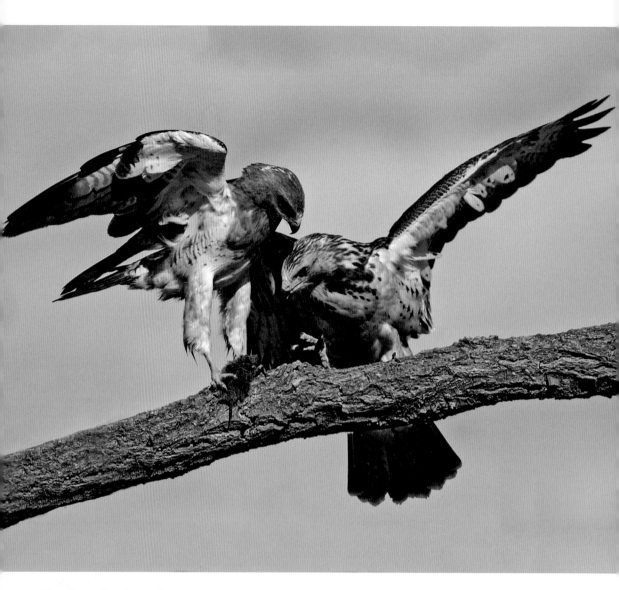

Feeding the Brood

above—This adult Swainson's hawk (left) is bringing
food to its just-fledged youngster (right). The food
is most likely a vole or a mouse. This is the greatest
portion of their diet, although they will eat small
birds, reptiles, and amphibians as well.

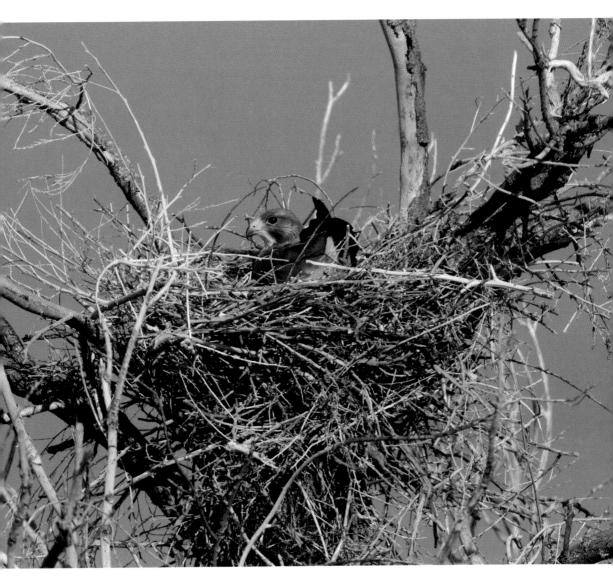

Female Brooding

above—A female Swainson's hawk brooding on eggs. Out on the plains, the nests are almost always found in smaller trees. Typically, they are found near the tops of the trees and hidden behind branches—especially when the trees get their leaves.

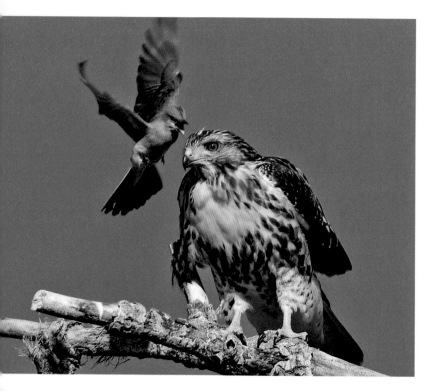

Harassment

left, top and bottom—Many small birds will take the opportunity to harass young hawks—especially when they can't fly very well. This young Swainson's hawk had to sit there and take the abuse from a western kingbird.

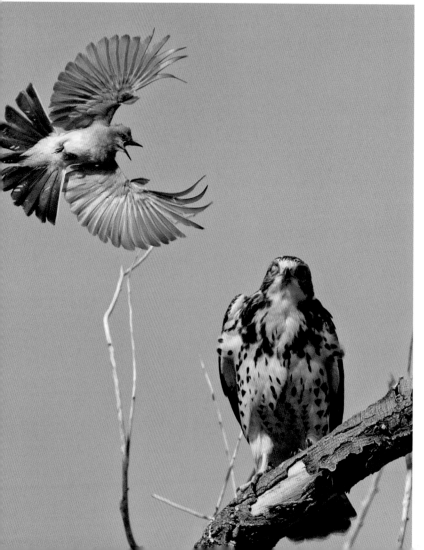

facing page, top—Here an adult Swainson's hawk is being harassed by an eastern kingbird.

facing page, bottom—The same hawk was also harassed by a western kingbird and an eastern kingbird. It must not have been his day! The hawks will sometimes raid a kingbird's nest and eat the young, so the parent birds will do anything they can to drive off the potential threat.

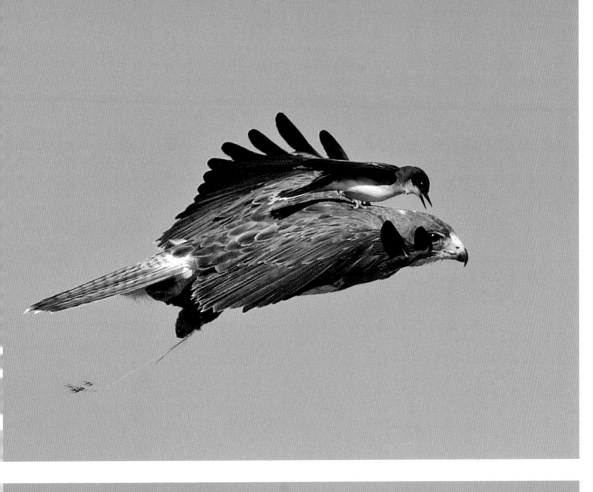
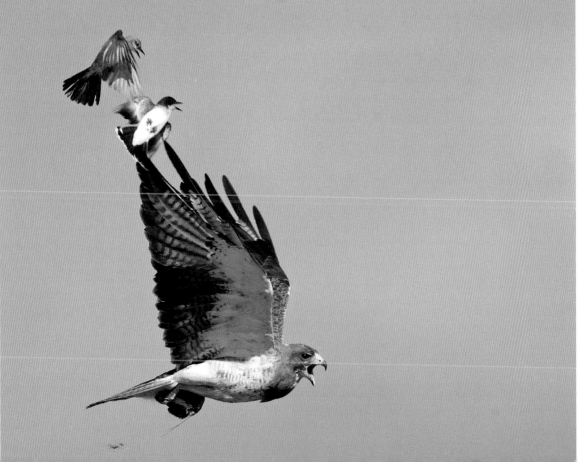

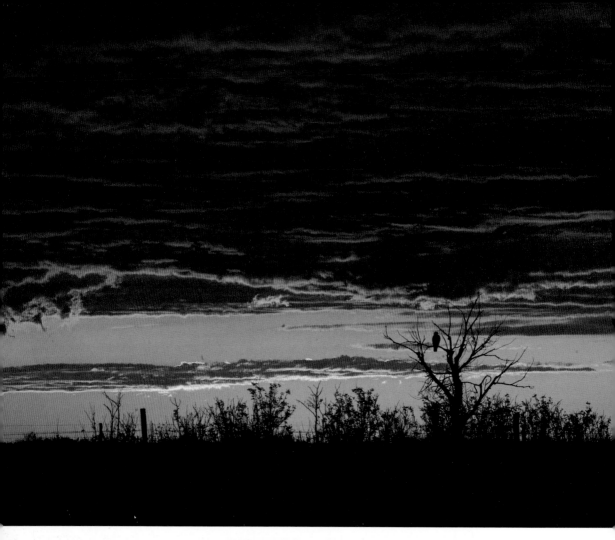

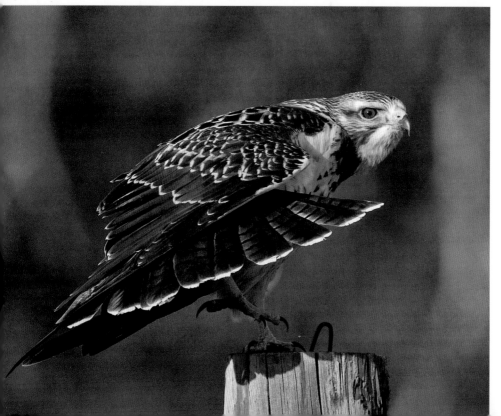

Sunset Silhouette

above—A beautiful sunset with the silhouette of a Swainson's hawk on the prairie.

Warble

left—A young hawk stretching her wings. This type of stretch is called a "warble."

Ferruginous Hawks

right, top and bottom—
Ferruginous hawks
inhabit the open
plains and deserts.
You can often find
them sitting on
fence posts, tele-
phone poles, or lone
trees—or soaring high
above.

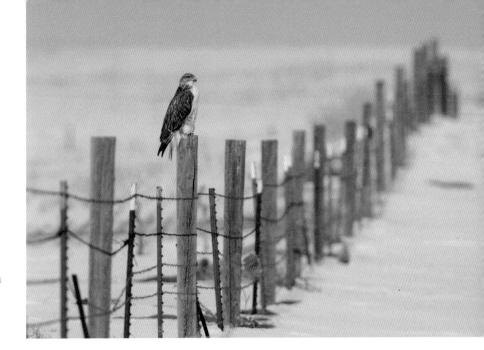

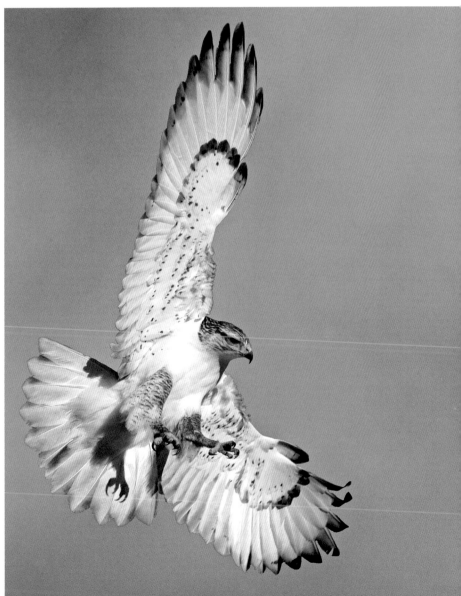

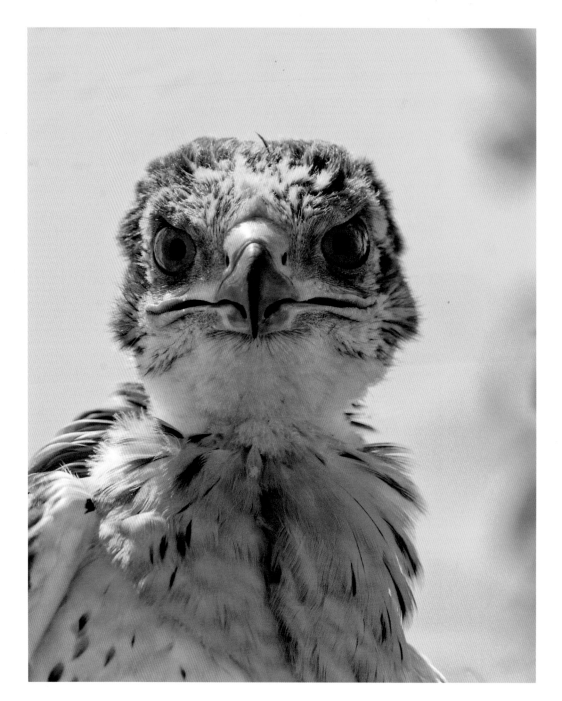

If Looks Could Kill

above—This young ferruginous hawk gave me a stern look from its nest site on the Pawnee Grasslands in northeast Colorado. Ferruginous hawks are the largest of all the broad-winged hawks, with a wingspan of nearly 5 feet. They are found throughout the west in open grasslands and deserts.

Coloration

facing page, bottom—The normal brownish-red colors of ferruginous hawks are seen in this photo. The bird's coloration is what gives it its name: "ferruginous" means "containing iron oxides or rust."

Hunting

right—Ferruginous hawks feed mainly on rodents, from mice to prairie dogs. They have huge mouths that are good for swallowing whole rodents very quickly before other raptors, especially eagles, try to rob them of their prey.

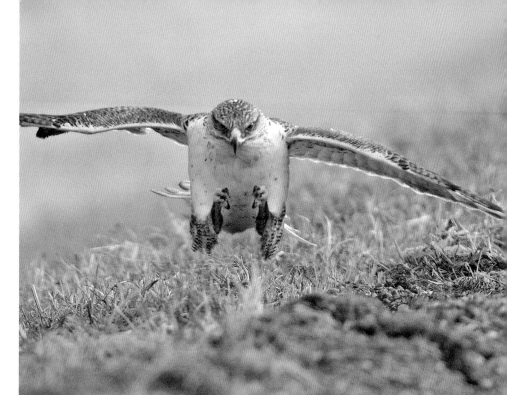

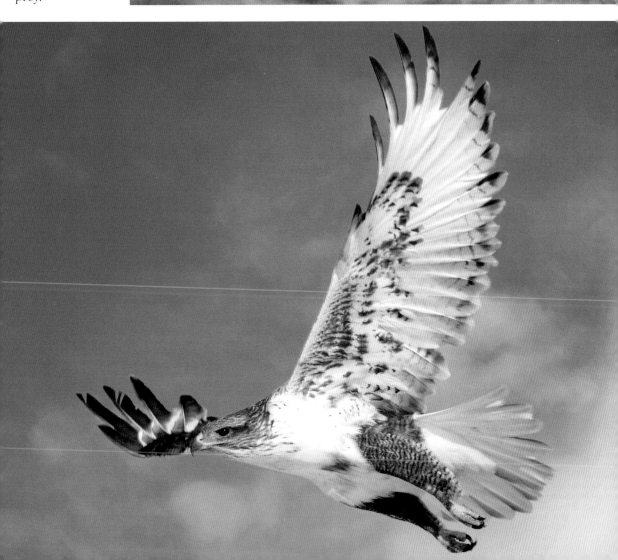

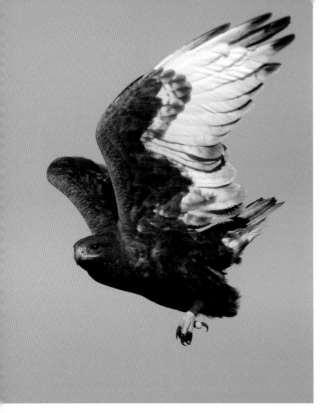

left and below—This is the dark morph of a ferruginous hawk. They are less common than the normal morph but just as beautiful. They remind me of a small eagle.

facing page, top—The most uncommon of the morphs of the ferruginous hawk is the rufous (or red) morph. I have only seen a few of these in the last twenty years.

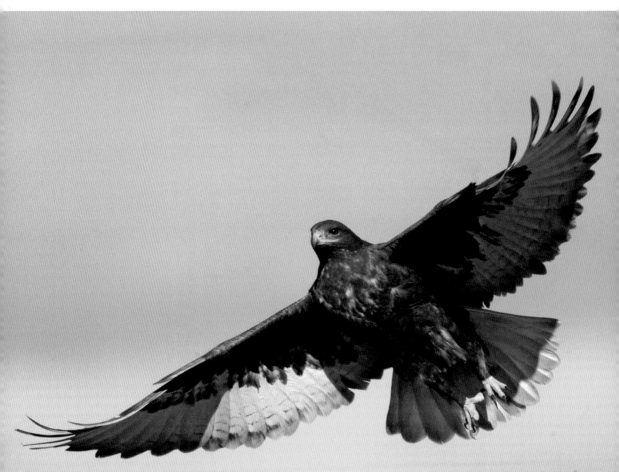

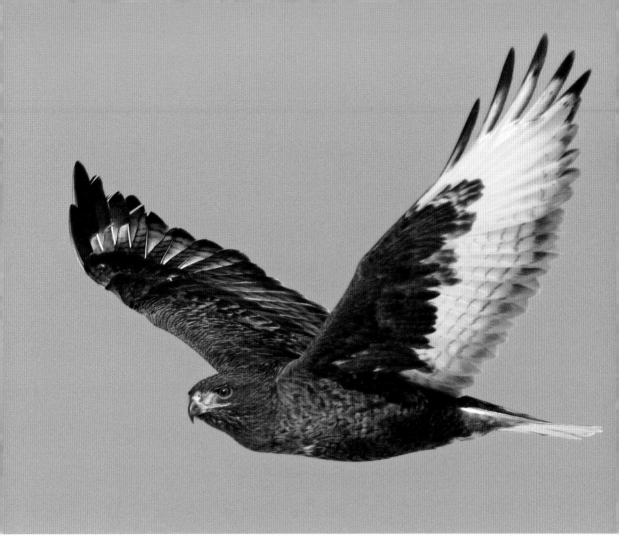

Nesting

right—Ferrugi-
nous hawks
will nest on
cliff ledges, the
tops of buttes,
or even lone
trees out in the
prairie. If not
disturbed, they
will come back
every year and
build on the
nest—bringing
in sticks until
the nest gets
very large.

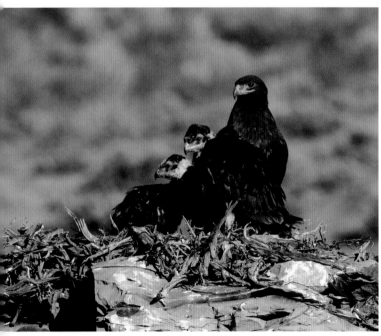

above—This stick nest sits in a lone tree on the prairie. You can see the female brooding on the eggs during a spring snow shower.

left—Here is a nest on top of an spire in Wyoming. Two of the three youngsters were dark morphs and one had more normal coloration. The bird on the right is an adult male.

right—Another nest on a spire with four-week-old chicks. Note how large their beaks are.

Adult Female

below—An adult female ferruginous hawk flying directly over my head in the winter.

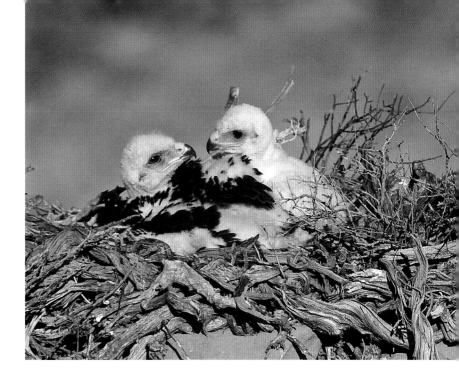

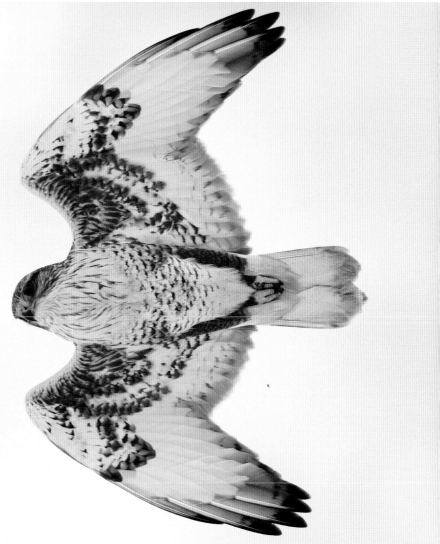

Rough-Legged Hawks

below—Rough-legged hawks love the winter. They are common residents of the plains and other northern climates in the cold months, but spend their summers in the arctic regions.

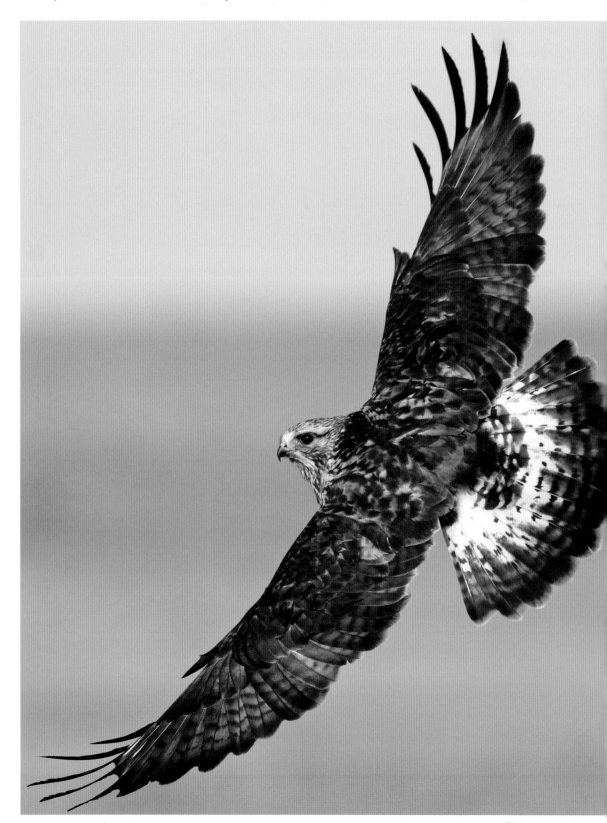

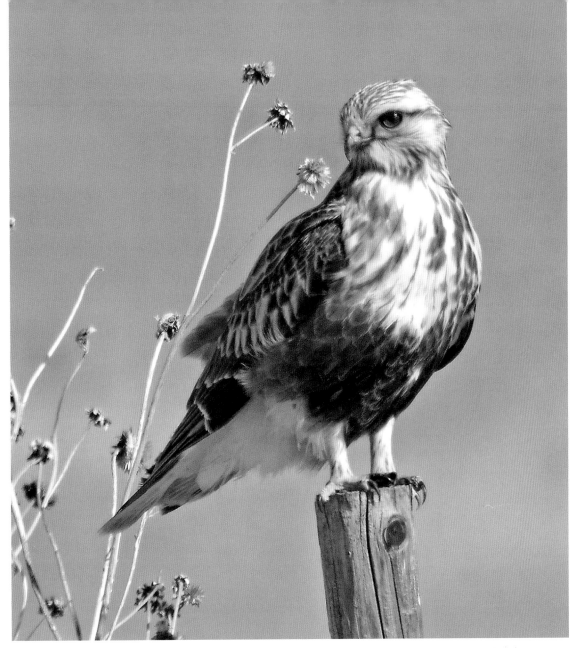

Hunting

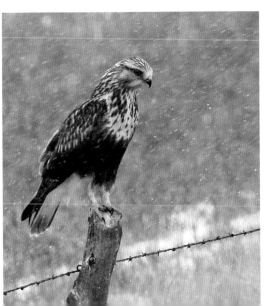

above and left—If you travel the dirt roads of the great plains in the winter, this hawk may be one of the birds you see hunting from fence posts and telephone poles. They feed almost entirely on small rodents. Rough-legged hawks have very small feet and probably could not handle anything larger than a prairie dog.

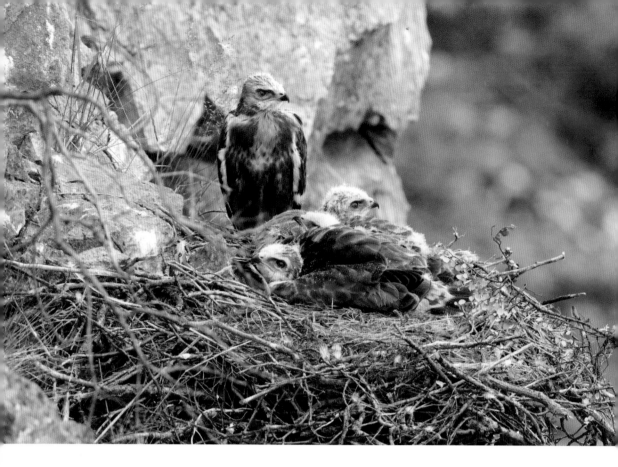

Youngsters

above— A few years ago, I spent some time up in Alaska looking for these raptors and other birds. I found a few nests and they were always on the side of a cliff overlooking a valley.

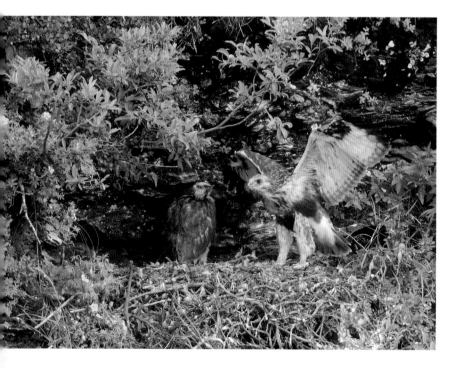

*left—*Here, one of the youngsters is exercising its wings while a younger sibling takes a look. These birds will fledge in the next week or so.

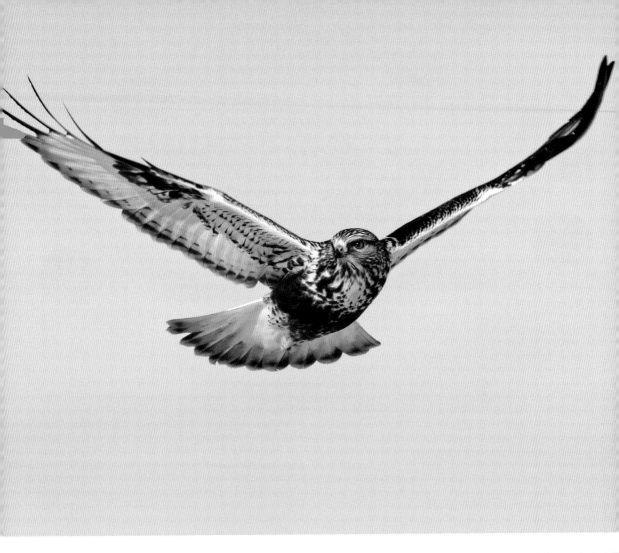

In Flight

above and right—
As they soar, these rough-legged hawks are beautiful with their various colors and impressive wingspread.

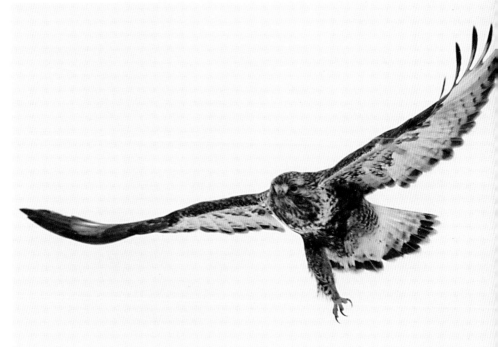

Red-Shouldered Hawks

below—Red-shouldered hawks are a medium, crow-sized birds that can be found in the southern United States from Florida to Texas and also in California. They feed on reptiles, amphibians, insects, and small birds.

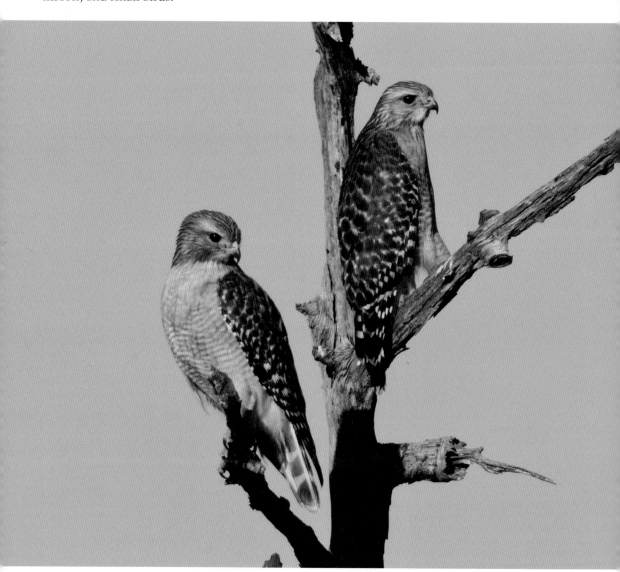

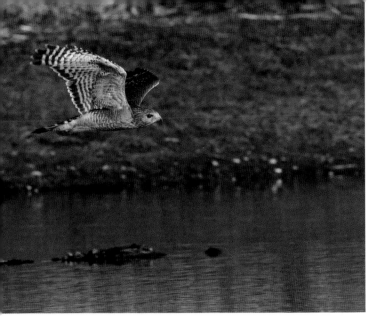

A Frog for Dinner

left—In many areas, you can find red-shouldered hawks flying low over water, looking for frogs hanging out by the water's edge.

below—This red-shouldered hawk was found sitting in an evergreen tree with a frog it had caught. This is a typical prey item for the hawk.

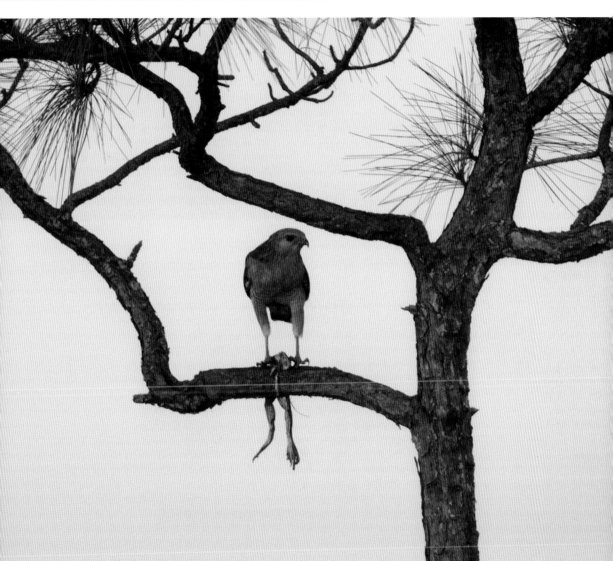

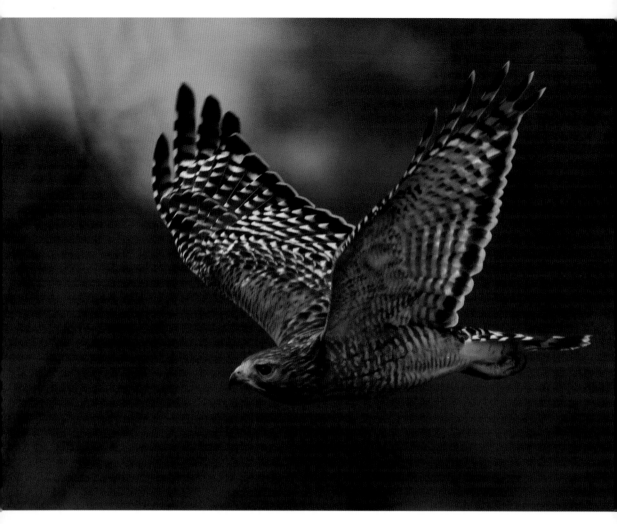

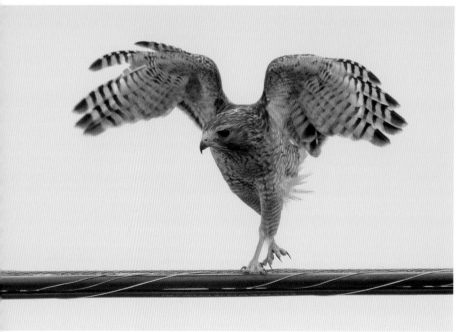

Tell-Tale Signs

above—The barred wings and red shoulders are a tell-tale sign that you have found a red-shouldered hawk.

On the Wire

left—These hawks love to walk the tightrope and sit on the thick wires between telephone poles.

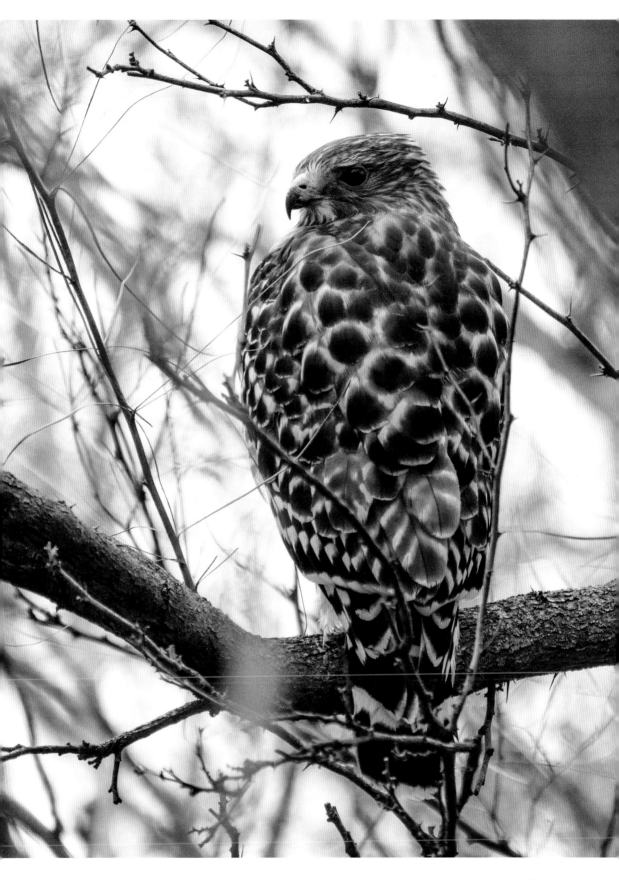

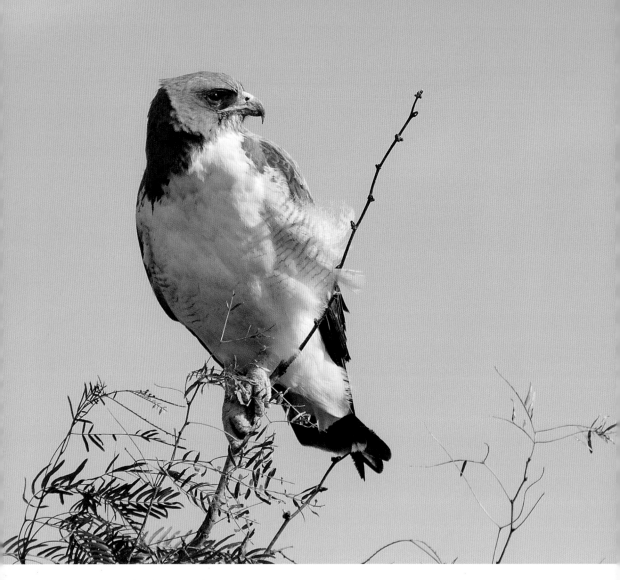

White-Tailed Hawks

above and facing page—White-tailed hawks are large birds found in south Texas and Mexico. They are very much like red-tailed hawks in their habits, commonly found soaring above a field or hunting from a tree, pole, or fence post. White-tailed hawks eat mainly rodents, some reptiles, and mammals up to the size of a rabbit.

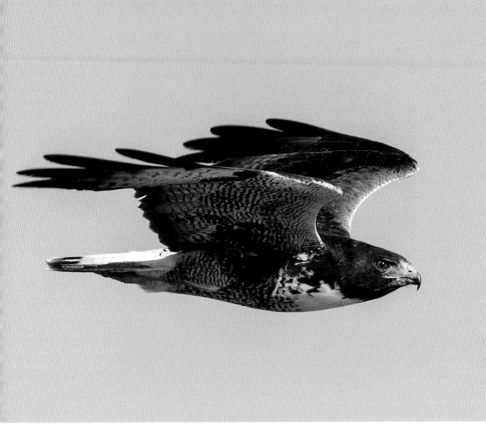
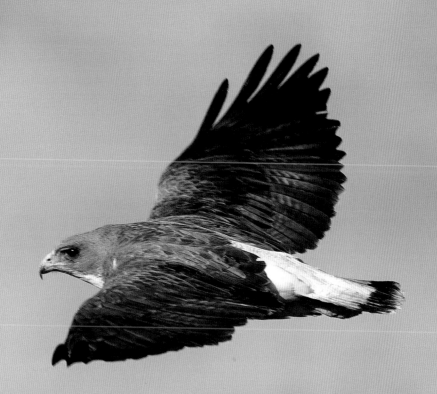

Perches

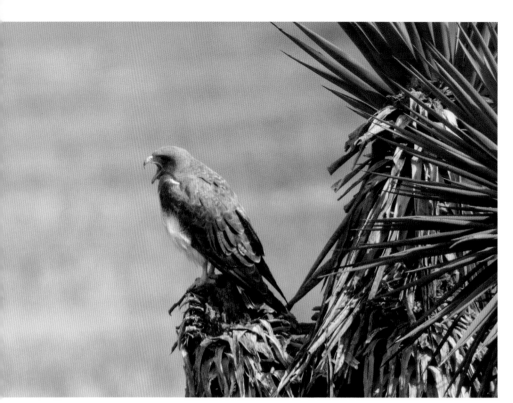

left—A white-tailed hawk sits on a yucca plant, surveying the field in front of him for prey.

below—An immature white-tailed hawk on a fence post. The immature birds look nothing like the adults.

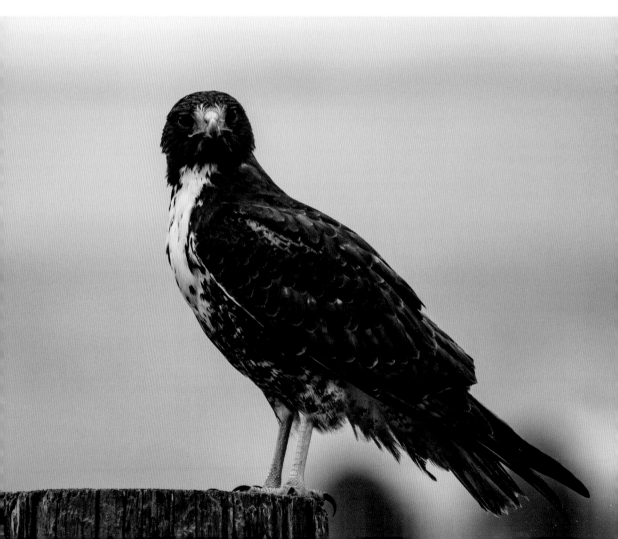

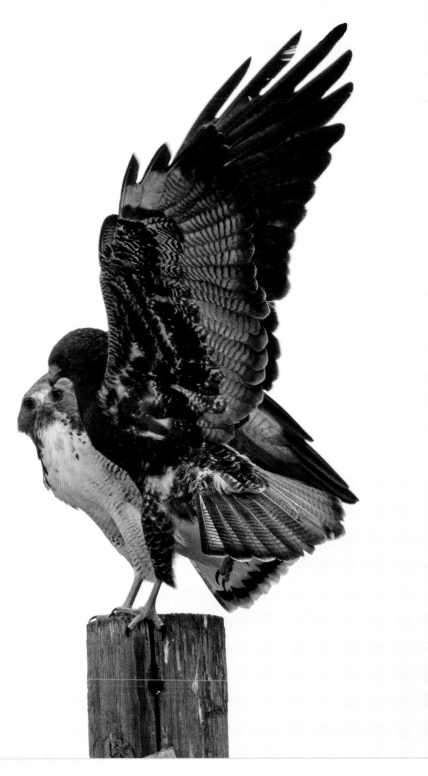

Sharing Space

above—An immature bird attempted to share a
telephone pole with an adult. This lasted for
only a second before the adult scared him away.

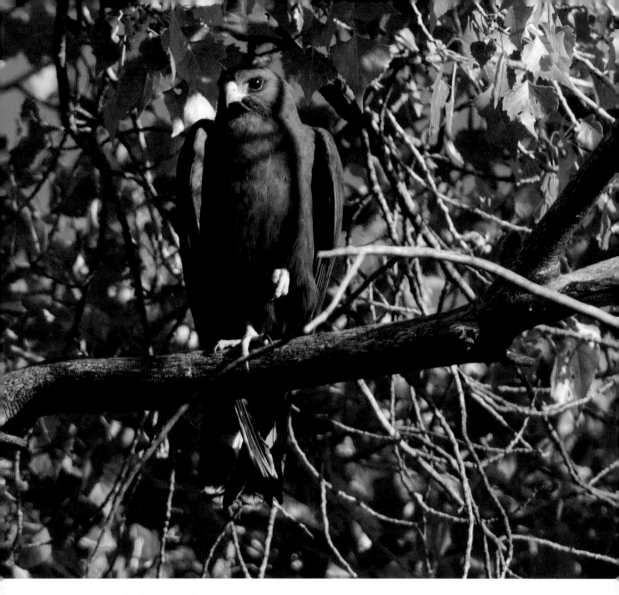

Zone-Tailed Hawks

above and facing page—Zone-tailed hawks are found in the deserts of the southwestern United States. They feed on a variety of prey, with reptiles and rodents being the main component of their diet.

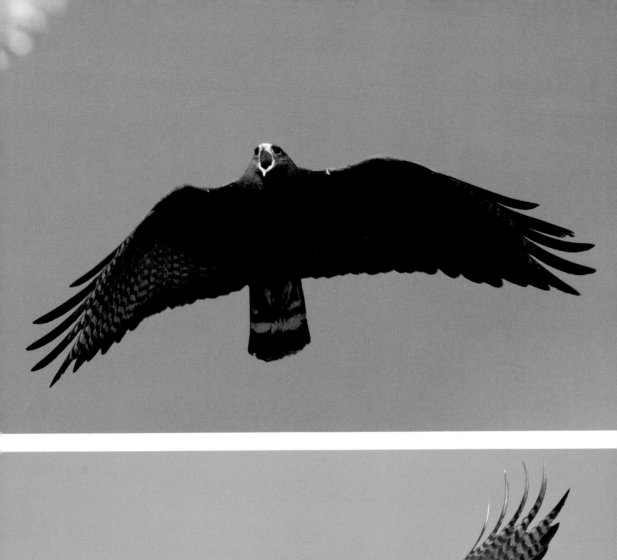

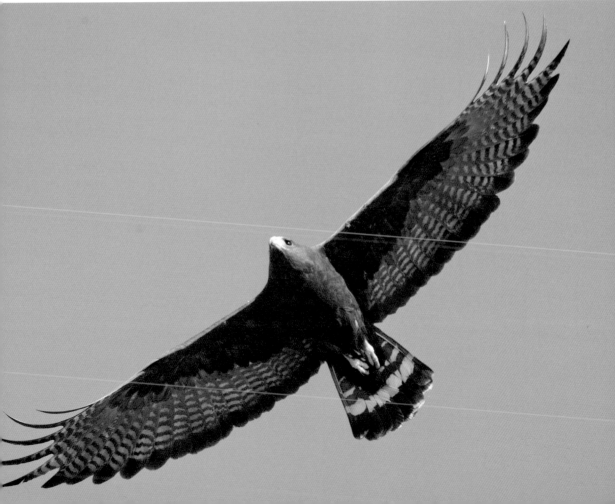

Gray Hawks

below—Gray hawks are another southwest species found in southeastern Arizona and Mexico. They are medium-sized hawks—about the size of crows. They feed mainly on rodents and reptiles but will also pursue small birds.

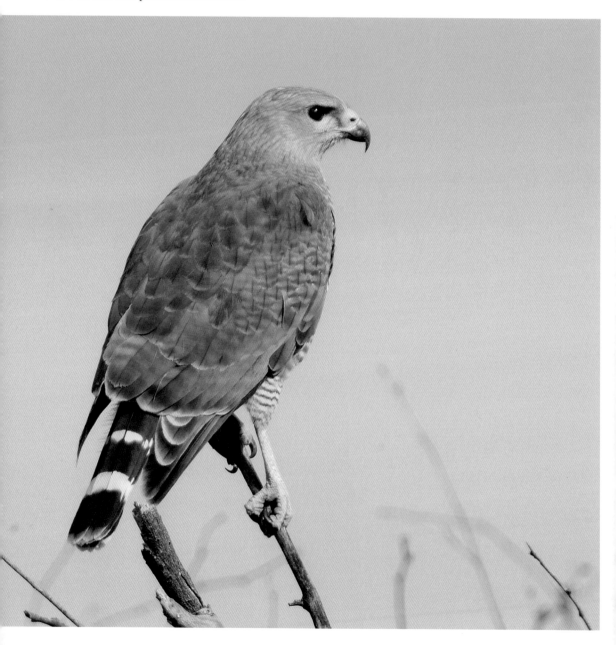

Cottonwoods

left—Gray hawks can be found around creeks where very tall cottonwoods grow.

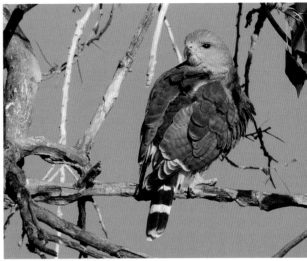

right and below—Here is a front side and a back-side view of a bird in a cottonwood in Nogales, Arizona. Although they pose well, they are still very hard to locate.

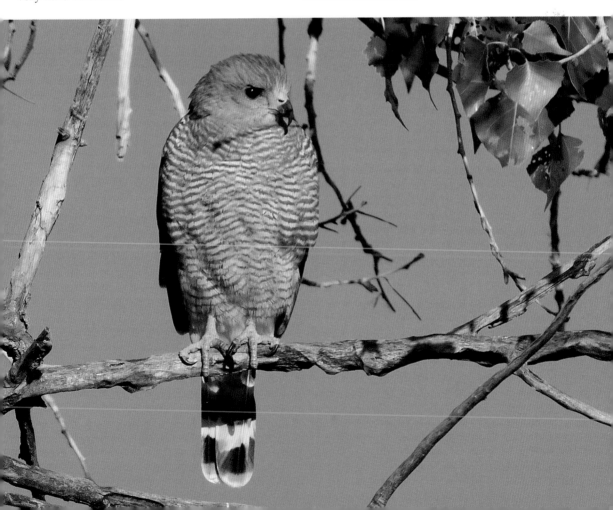

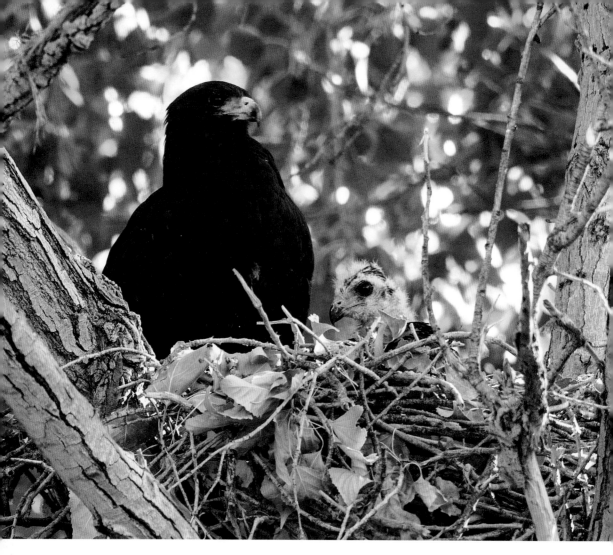

Common Black Hawks

above—Another southwest raptor is the common black hawk, which is actually not very common at all. There may be more in Mexico, but they are pretty rare in the United States. *Photograph by Nick Dunlop.*

Intrusion

facing page, top—In this photograph, we see an adult common black hawk that is voicing his disapproval of an intruder that had strayed too close to the hawk's nesting site. *Photograph by Nick Dunlop.*

facing page, bottom—In this case, the disapproval is from a mockingbird. The hawk must have flown too close to the mockingbird's territory and he is escorting the hawk out of the area. Smaller birds are more maneuverable and usually are not in any danger when attacking a hawk in the air. *Photo by Nick Dunlop.*

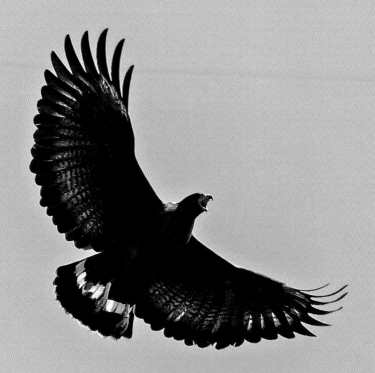

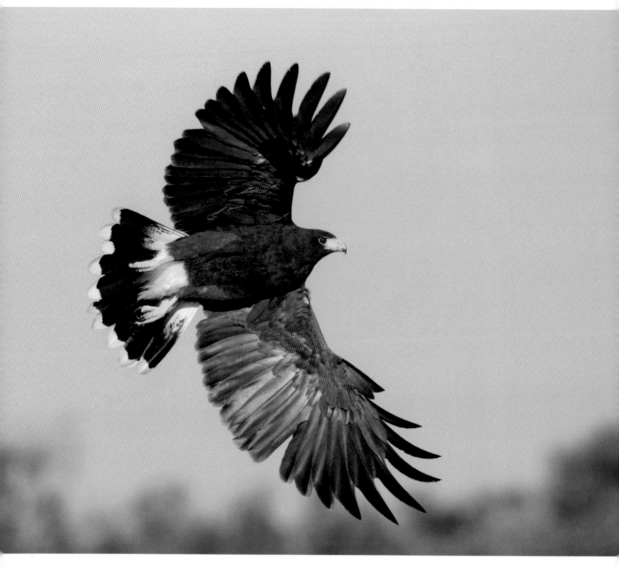

Harris's Hawks

above—The last of the southwest raptors (although certainly not the least) is the Harris's hawk. These beautiful raptors are found throughout southern Arizona, New Mexico, and southern Texas.

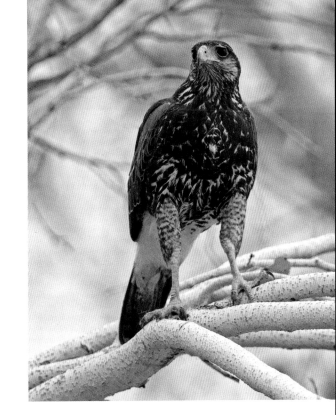

right—A portrait of an immature Harris's hawk.

below—An immature bird hanging out at a local park in Phoenix, Arizona.

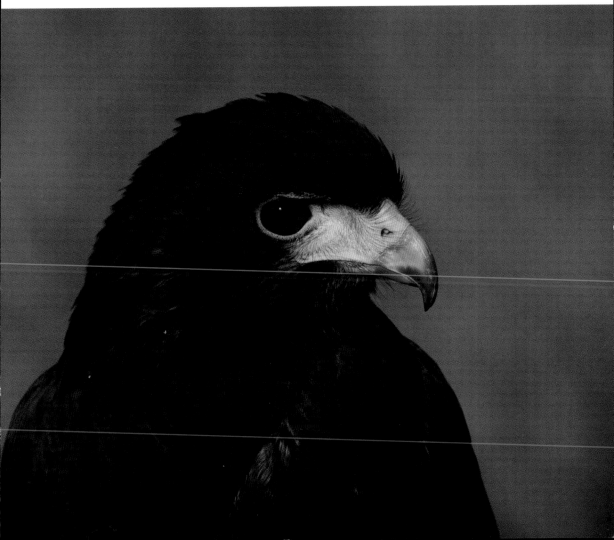

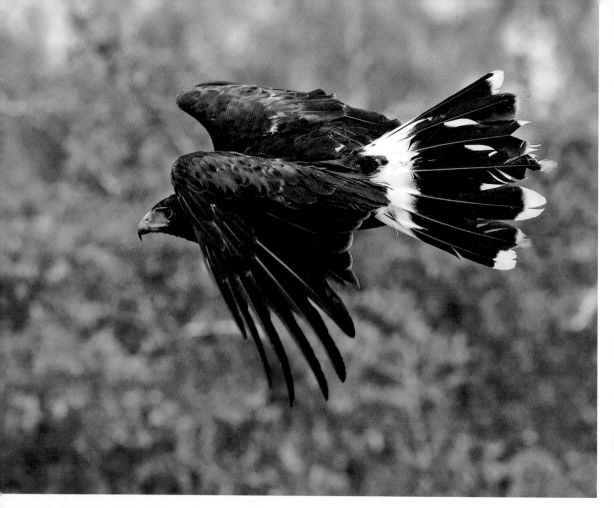

Hot Pursuit

above—This is a Harris's hawk in hot pursuit. These are the only hawks that are known to hunt their prey in groups. You can commonly see up to five or six hawks hanging out in the same area. If one of them spots a prey item, like a rabbit, he will chase it and the others will join in the hunt. This increases the odds that the rabbit will be caught.

left—A beautiful immature bird.

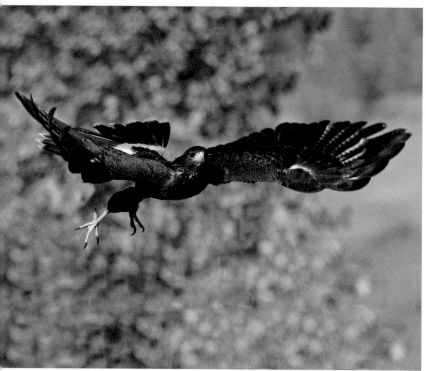

Broad-Winged Hawks

Broad-winged hawks are common in the eastern Uniter States and Canada. Their preferred habitat is dense forest, and they are fairly small (smaller than a crow). Seeing one perched, rather than flying, is a rare treat. When they migrate, they collect into large groups called "kettles." They will find a warm air current and fly up into it, then let the southerly winds blow them south on their migration. In certain areas, as many as 10,000 hawks will fly by on any given day.

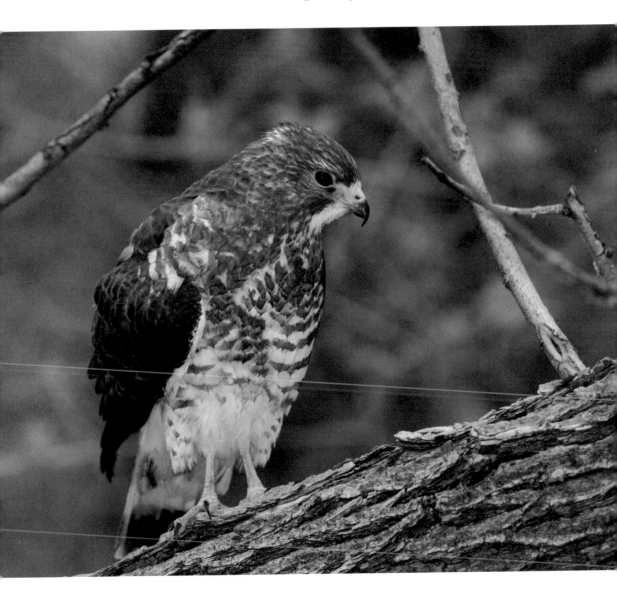

3. Eagles

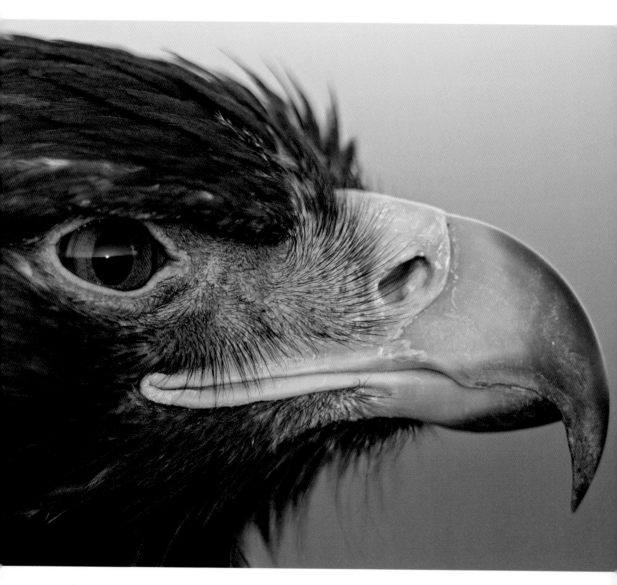

Golden Eagles

right—The golden eagle is a magnificent bird that symbolizes freedom and fierceness in their truest forms. In my humble opinion, I think the golden eagle should be our national bird. Its counterpart, the bald eagle, is truly regal as well—but it is commonly known as a thief, stealing prey from other birds or just plain eating dead fish. The golden eagle is a true predator and eats and kills most of its prey, unless conditions are slim.

Mating for Life

right—Like most raptors, eagles mate for life. Here we can see the adult male on the left and the female on the right. The female is approximately one-third larger than the male, with the male weighing in from 5–7 pounds and the female 9–12 pounds. Note that both the eagles have full "crops," the area below the chin. This means they have both shared a nice meal of some prey item. In this case, it was a black-tailed jack rabbit.

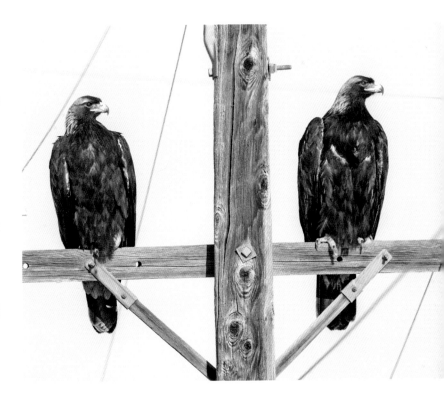

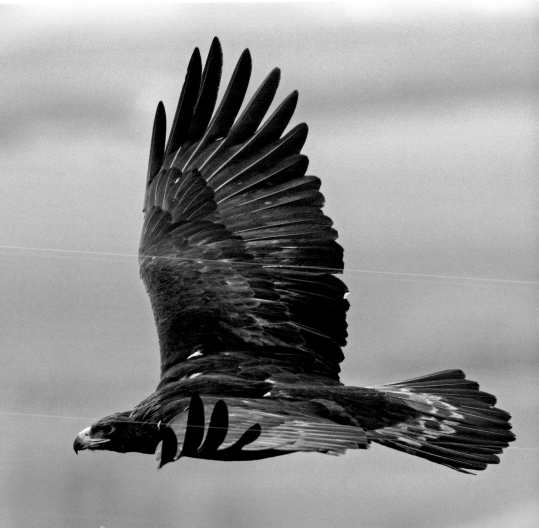

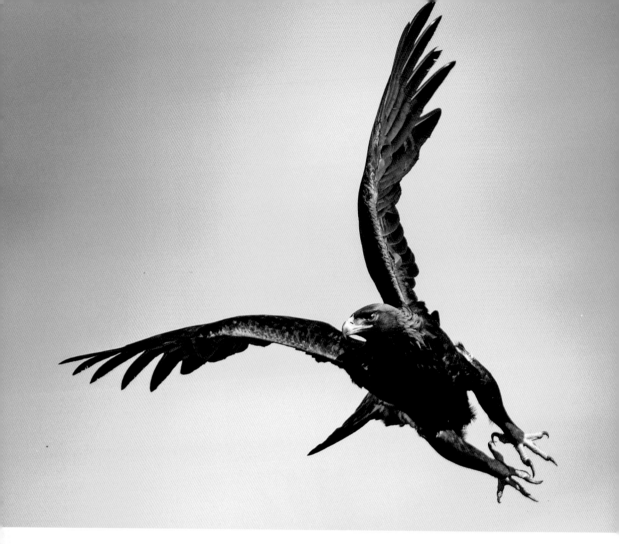

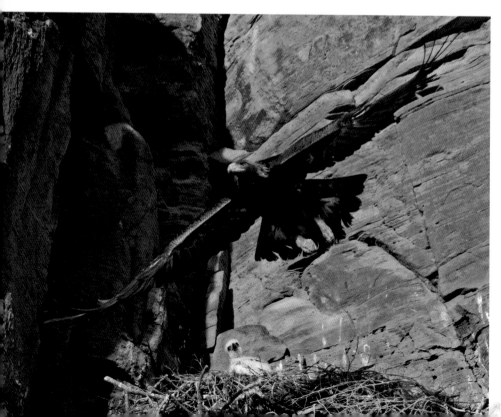

The Nest Site

left—An adult eagle leaving the nest site on a cliff in Colorado while a young eagle watches from his high point of view.

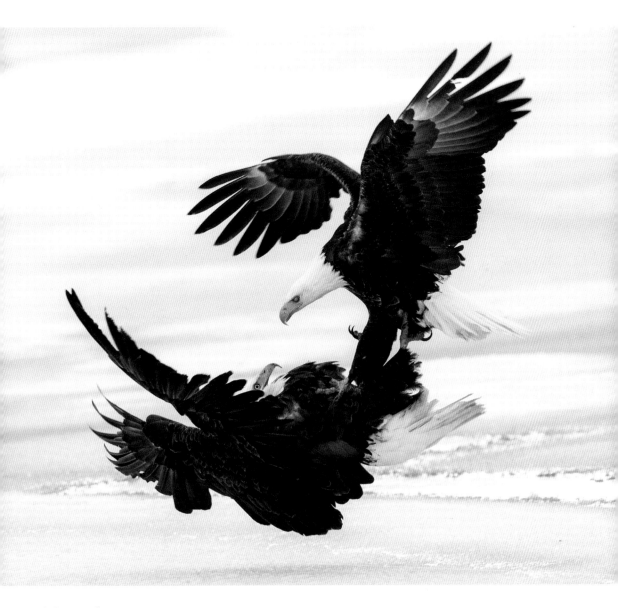

Bald Eagles

above—Bald eagles are found in North America. They are very common throughout the continent, from the west coast to the east coast, and from Canada to Mexico.

The bald eagle is certainly a gorgeous bird, and it's easy to see why it was chosen as the national bird of the United States. However, their habits are a little less than stellar. In this photo, the two eagles are fighting over the rights to a fish that is lying on the ground—a fish that was dropped by the lower eagle.

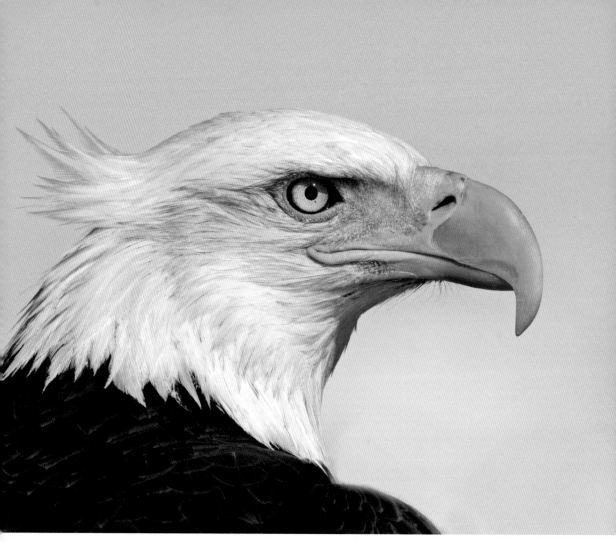

Eagle Portrait

above—Portrait of an adult bald eagle.

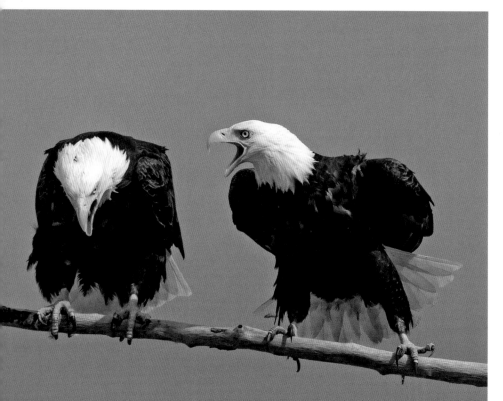

What Are They Saying?

left—This photo is just begging for a caption. I like, "I didn't mean to burn the soufflé!"

Immature

right—An immature bald eagle flying by.

Territorial Dispute

below—Although it looks like these eagles are engaged in mortal combat, this is just a territorial dispute. No eagles were harmed in the taking of this photo.

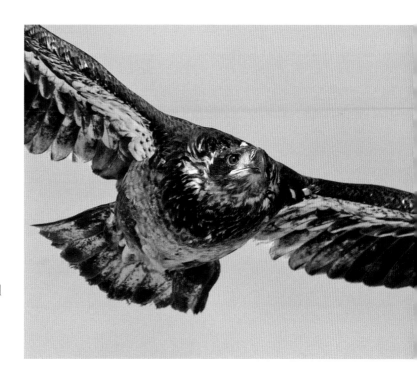

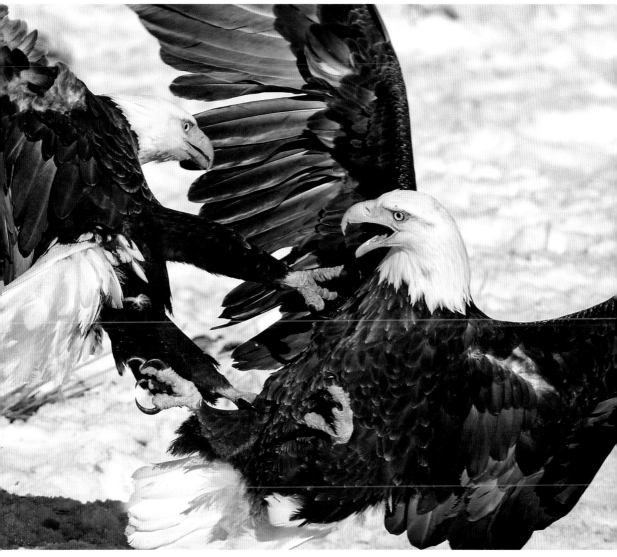

Hunting

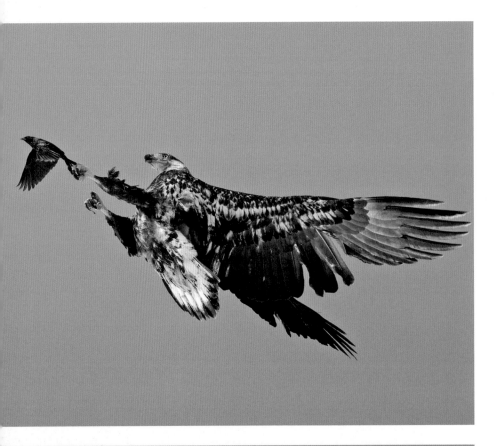

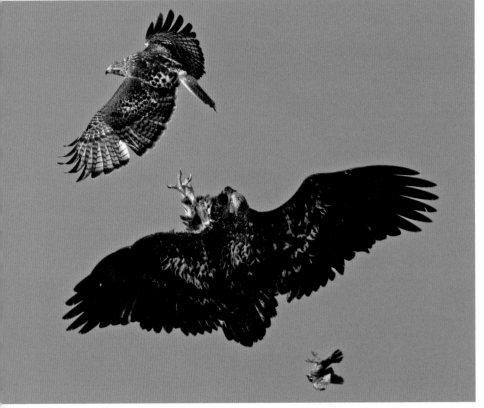

top left—In most cases, bald eagles will not attempt to catch a small bird in midair. Here, however, the blackbird had been poisoned by a pesticide which affected its brain. It flew along as though unaware of the eagle's pursuit and thus ended up as lunch for the larger bird. I was concerned that the eagle might also ingest the poison and be impacted by it, but I saw no sign of that being the case.

bottom left—An immature red-tailed hawk has dropped a blackbird because the eagle was about to grab the hawk in order to get the blackbird. The blackbird fell to the ground and neither the eagle nor the hawk got the prize.

4.
Osprey

Ospreys are the true fish hawks of North America. Unlike bald eagles, which I would call surface feeders, ospreys will plunge into the water to catch a live fish. Eagles skim the surface for either surface-feeding fish or just dead fish.

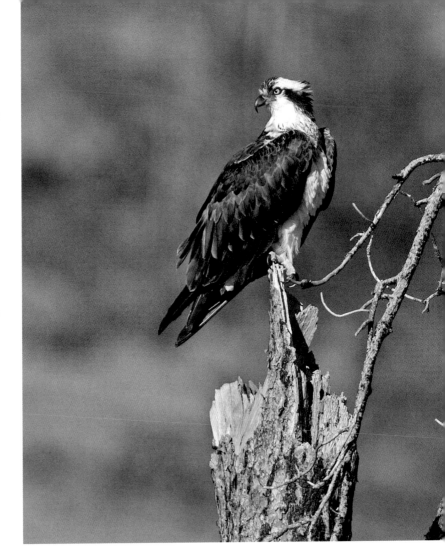

bottom right—A young osprey just before landing, late in the evening.

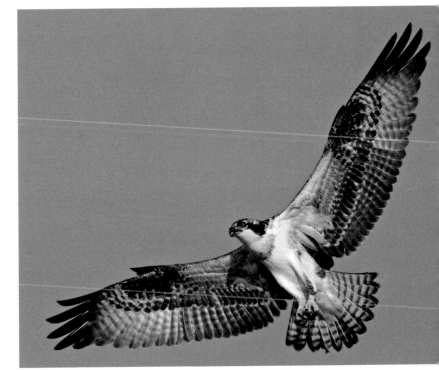

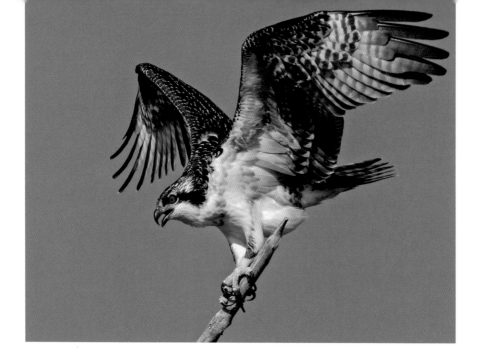

Too Close

below—Here, an adult osprey is being harassed by a western kingbird. This is because the osprey had flown a bit too close to the kingbird's nest— although an osprey would never stoop so low as to rob a kingbird of its young.

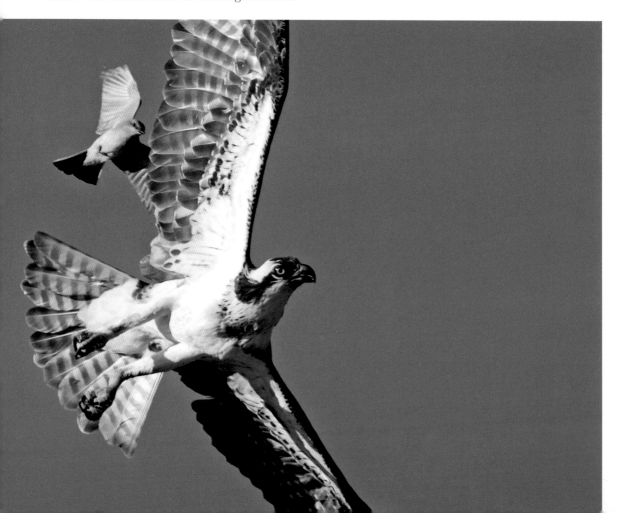

5. Vultures and Caracaras

Turkey vultures and black vultures, along with the crested caracara, are nature's waste disposal caretakers. They are an essential part of the ecosystem and can be found across North America, with the turkey vulture everywhere and the black vulture and caracara in the southern range.

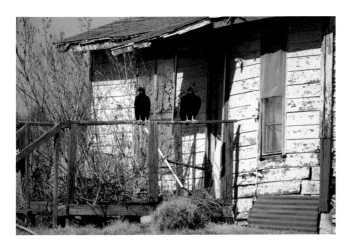

Black Vultures

left—Two black vultures sit on the doorstep of an abandoned house in central Texas. I wonder what's inside?

Turkey Vultures

below—These turkey vultures are sunning themselves on the California coast. The sun aids the vultures in ridding themselves of the parasites that are found in their feathers.

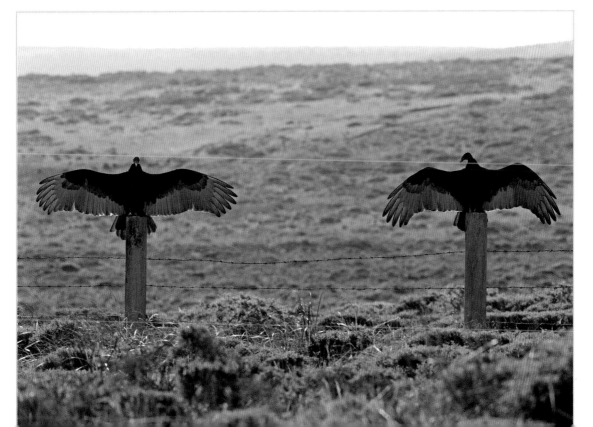

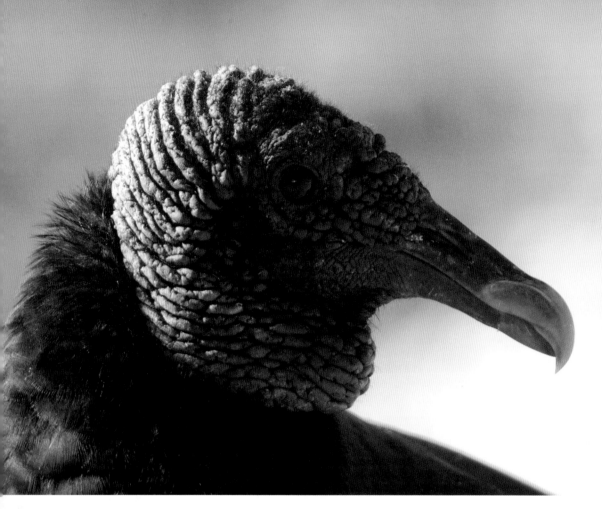

above— Notice that the vulture's head has no feathers. This prevents parasites from jumping off the dead animals the vultures eat and onto the body of the vulture itself.

Caracaras

left—Here a crested caracara is chasing a Turkey vulture near a carcass. There is a lot of territorial dispute around a carcass, such as a dead cow, to get the best food possible.

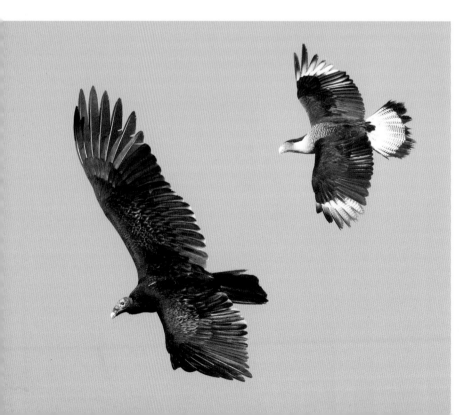

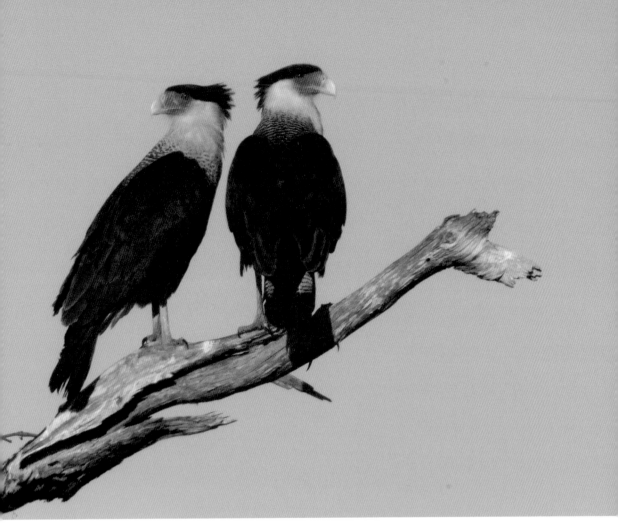

Waiting

above—Two caracaras wait on a dead branch for their meal.

Head Throw

right—The head throw demonstrated by the bird on the left is a common territorial display among caracaras.

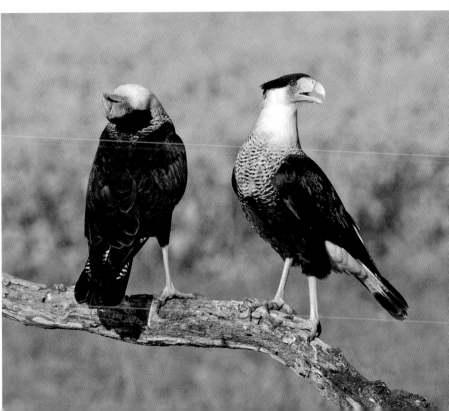

9. Northern Harriers

Northern harriers are raptors of the marshes and open plains. It seems they spend almost 90 percent of their time on the wing, coursing the fields for unsuspecting rodents, reptiles, and small birds. This one is an adult male, sometimes referred to as the "gray ghost." Since the females and the immature birds are brown, the gray male is not terribly common—so count yourself lucky if you get to see one of these stunning raptors.

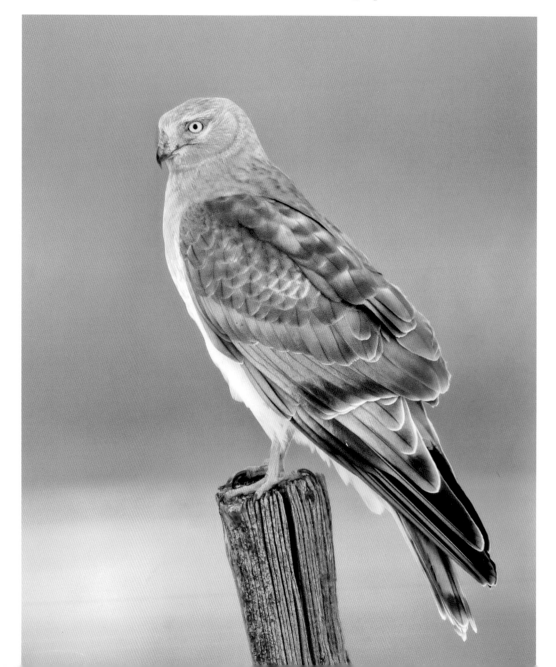

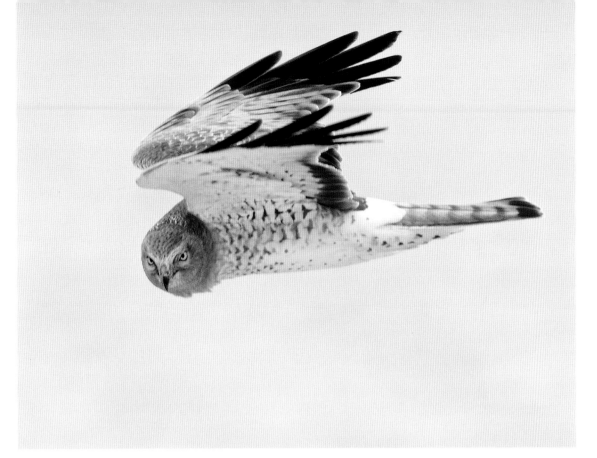

Male and Female

above—A male harrier focuses in front of him for a potential prey item.

right—A female harrier sitting on a fence post.

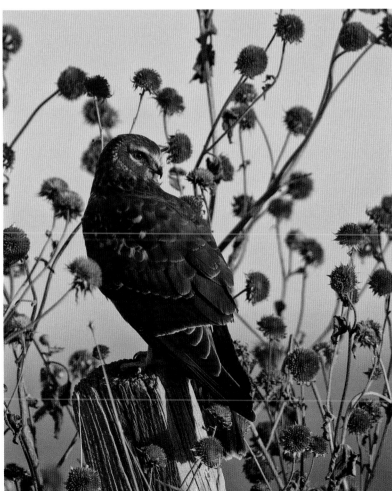

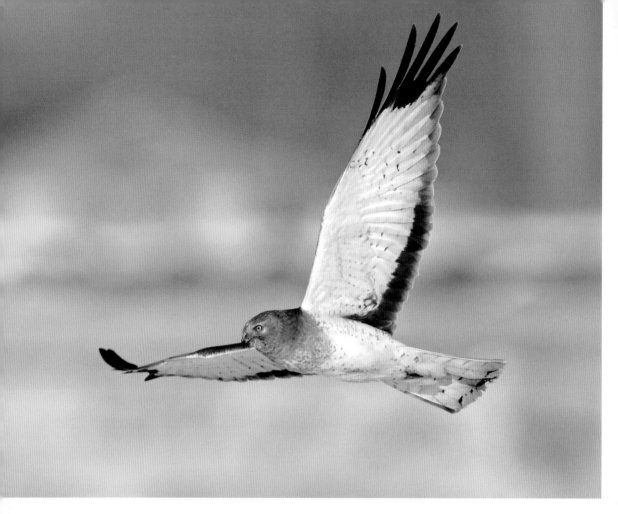

Quick Turns

above and left—Harriers are very adept at turning quickly in order to nab their prey.

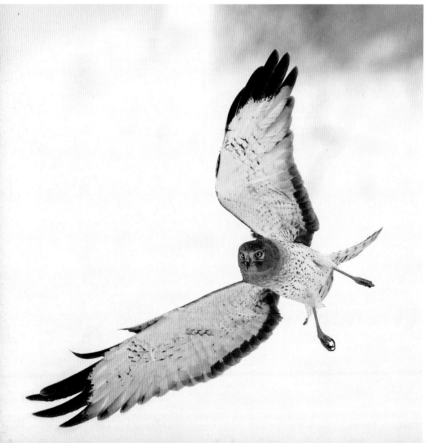

7. Kites

The next group of raptors are called kites. They are named for the way they hover in the air like a kite, although not all hover. They consist of four species: the snail kite, the swallow-tailed kite, the white-tailed kite, and the Mississippi kite.

Snail Kites

right and below—Snail kites are specialized and feed entirely on snails. They have very long beaks that can curve around the shell of the snail and pierce its body. The kite can then remove the edible flesh from the shell. Snail kites are found mainly in Florida and Mexico.

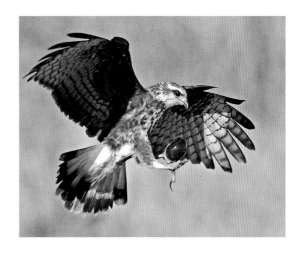

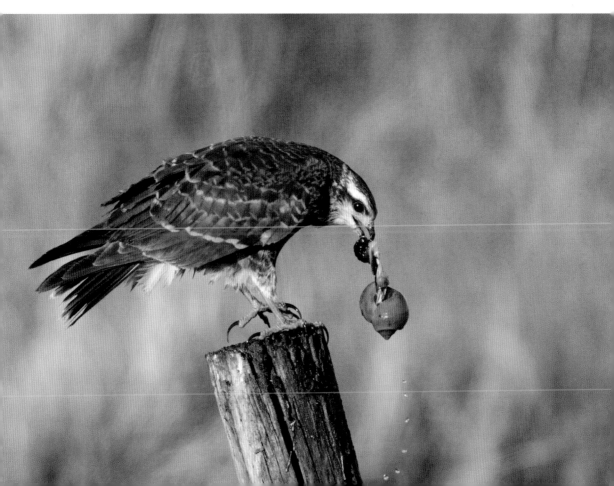

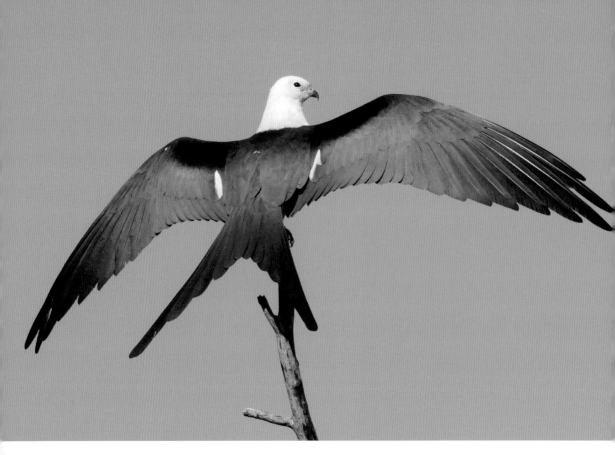

Swallow-Tailed Kites

above—Swallow-tailed kites make their summer homes in the southeastern United States; they winter in South America. These birds feed on flying insects, some reptiles and amphibians, and small birds. They are a species of concern in the United States as their populations seem to be decreasing throughout their range. *Photograph by Marina Scarr.*

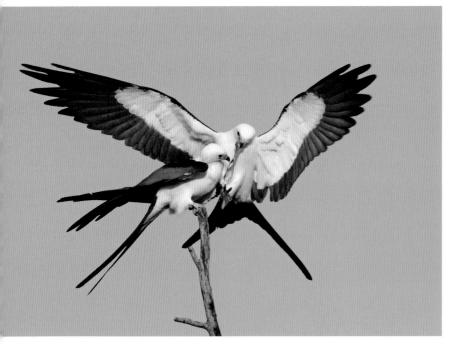

above—Here a mated pair of kites are trading off duties. The male is handing a frog to the female to be taken back to the nest. *Photograph by Marina Scarr.*

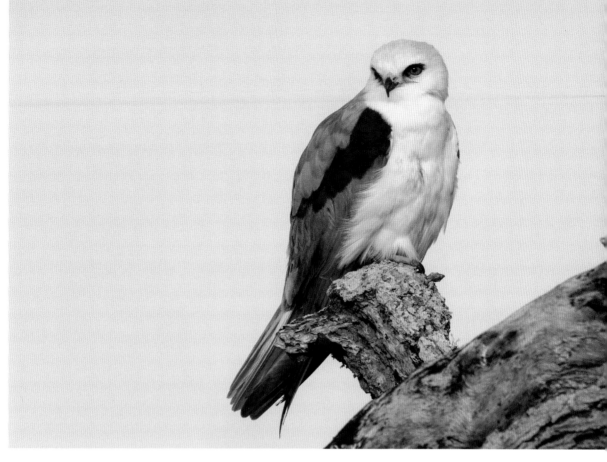

White-Tailed Kites

above—White-tailed kites are usually found along the coastal regions of the United States and Mexico. In other countries, the bird is known as the black-shouldered kite. Both names work for this bird.

right—A white-tailed kite with a vole. Again, notice the black shoulder and those amazingly red eyes.

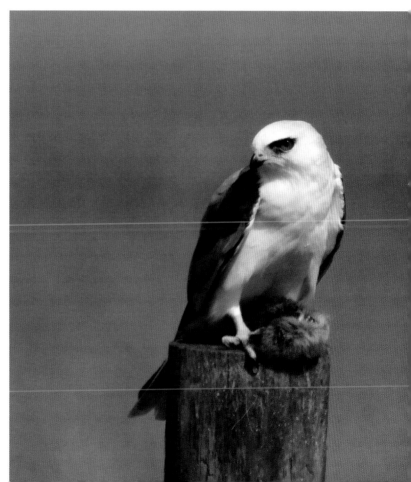

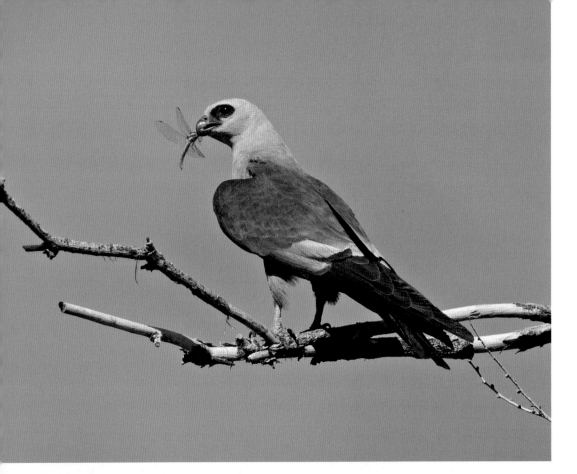

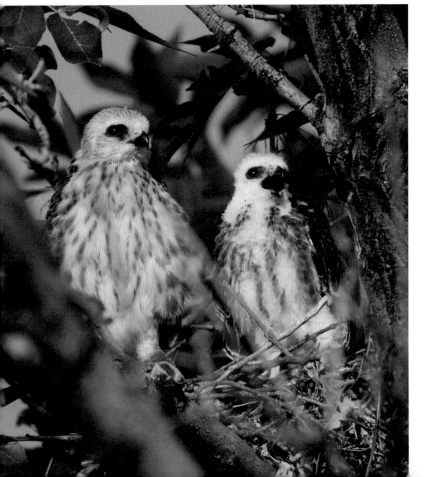

Mississippi Kites

above—Mississippi kites
are found mainly in the
southeastern United States,
although their range is
expanding. They have been
found nesting as far north as
Minnesota and they are now
common in Colorado as well.
They feed mainly on flying in-
sects and sometimes reptiles
or amphibians.

left—Here are two young
Mississippi kites awaiting a
dragonfly from one of the
parents in the flimsy nest at
the top of an elm.

8. Falcons

The falcons of North America are comprised of six species: the American kestrel (below), the merlin, the aplomado falcon, the prairie falcon, the peregrine falcon, and the gyrfalcon. During my lifetime, I have had the pleasure not only to study and photograph these wonderful birds but I have also trained and released each of these species.

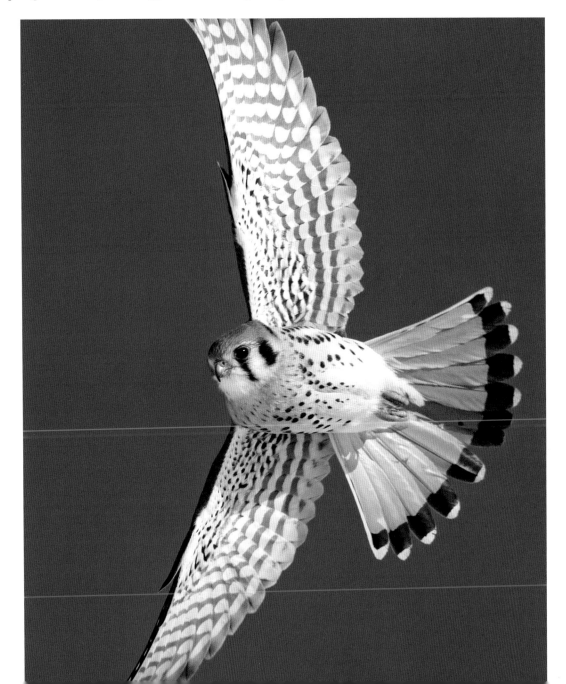

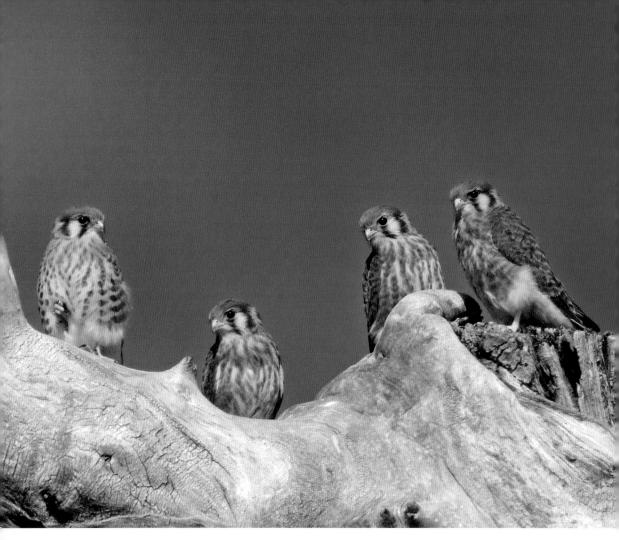

American Kestrels

above—Here is a group of four young-sters, outside the nest hole for the first time. These little ones (three females and one male) are about thirty days old and cannot fly yet. When I was twelve, I climbed one of these trees and a young kestrel fell out. I took him home, fed him, and a couple days later let him go. He stayed around my backyard for five months, and I fed him grasshoppers and crickets. He slept on my bedpost every night and flew free during the day. Needless to say, I was hooked.

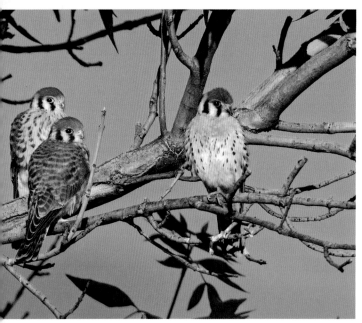

left—Three young kestrels awaiting food from a parent bird.

Almost Fledged

right—This little almost-fledged male kestrel was checking out a nearby sparrow.

Here Comes Dad

below—Here comes Dad with a tasty morsel. Kestrels will hunt for rodents and insects from perches like trees, telephone poles, and fence posts. They will also hunt from the air, hovering over a field in one place until they spot their quarry.

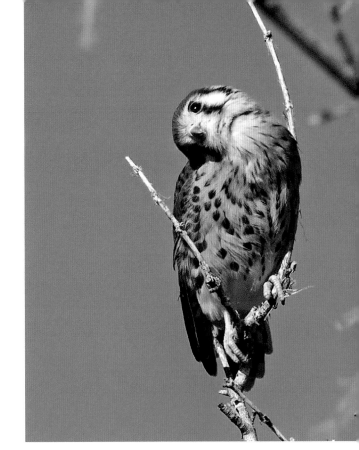

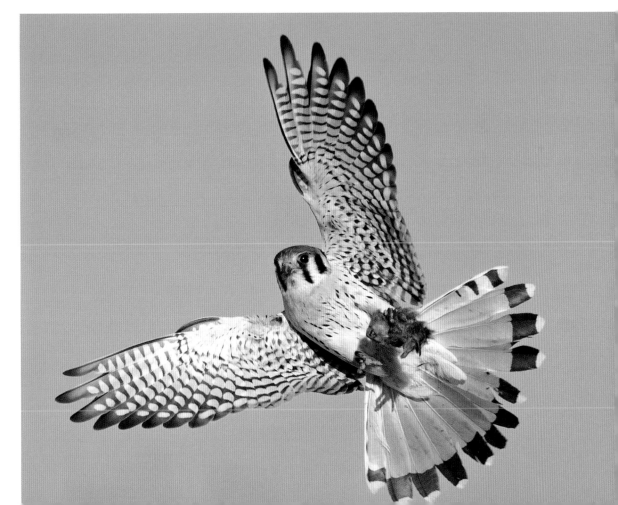

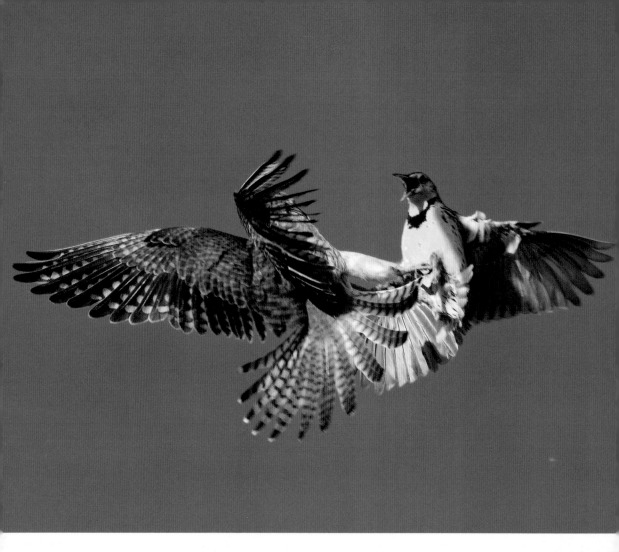

above—A female kestrel binds to a meadowlark. She attacked this lark that was sitting in her nest tree and caught him. When she took him to the ground, I thought she might kill him—but she let him go at the last moment. I don't think the meadowlark came back.

right—A young kestrel testing his wings.

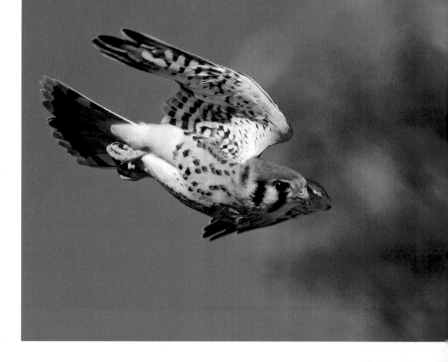

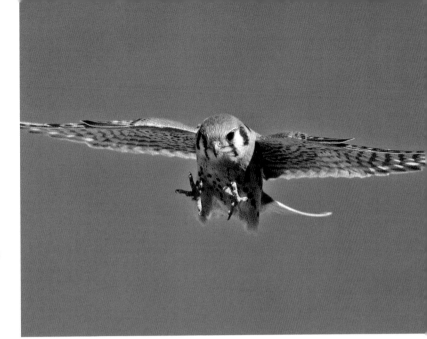

Mouse View

right—Here's what a mouse sees just before the strike!

Coming in for a Landing

below—A young male landing next to his female sibling.

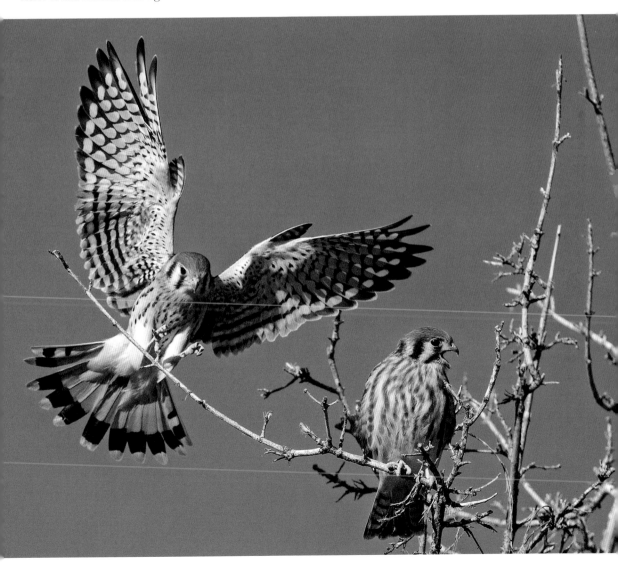

Coloration

left—The beautiful colors of a male kestrel. I think this is the most colorful of all the falcons.

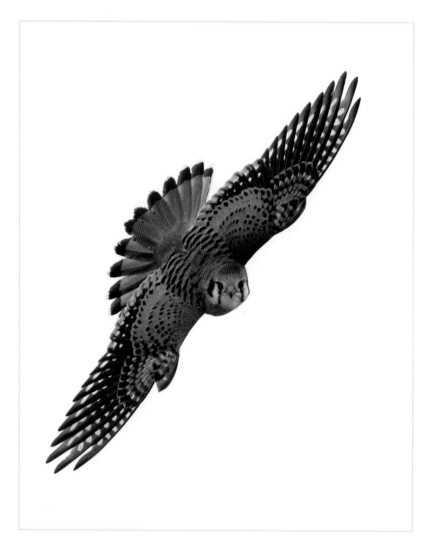

Kestrel Vision

facing page, top—This kestrel is hovering over an open field in search of prey. Kestrels can see in the ultraviolet light spectrum and they use this trait to track down mice. When they hover over a field, they can see the urine trails the mice leave and they will track the trails until they find the mouse—and then they pounce!

Kestrel Size

facing page, bottom—Kestrels are the smallest of all the North American falcons. An adult male kestrel weighs in at less than 4 ounces and the female just a little larger. While they are not much bigger than robins, these raptors are still quite a threat for any prey item their size or smaller.

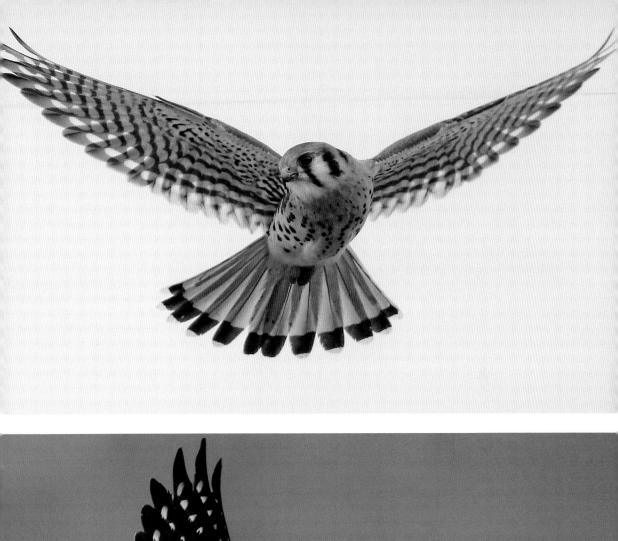
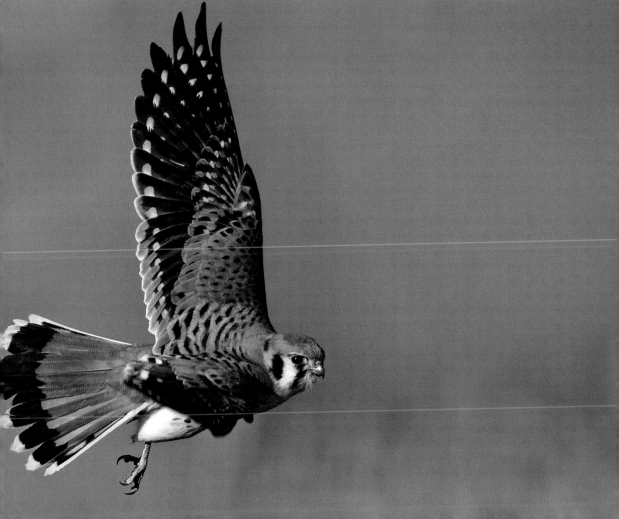

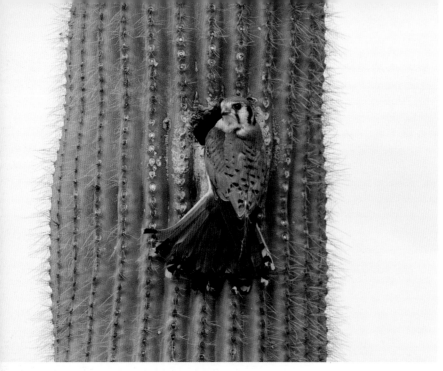

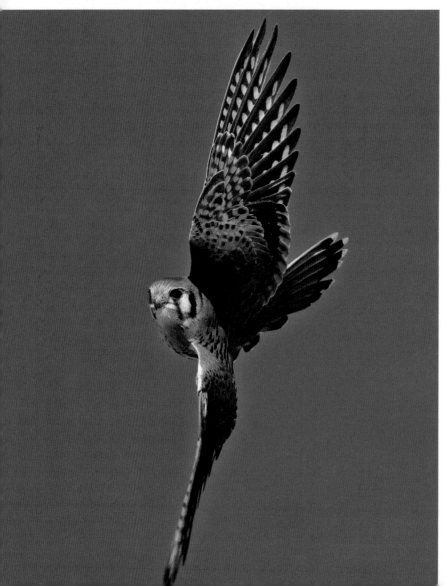

Population Size

top left—American Kestrels can be found throughout the United States, although their population seems to be decreasing—especially on the eastern seaboard. Here, one is nesting in a saguaro cactus in Phoenix, Arizona.

Changing Direction

bottom left—Kestrels are very maneuverable and can change direction quickly, like this one attempting to catch a grasshopper in mid-air.

Male and Female

right, top and bottom—These two images show the difference between the male kestrel (top) and the female (bottom). Although the heads are very similar, the rest of the body is quite different.

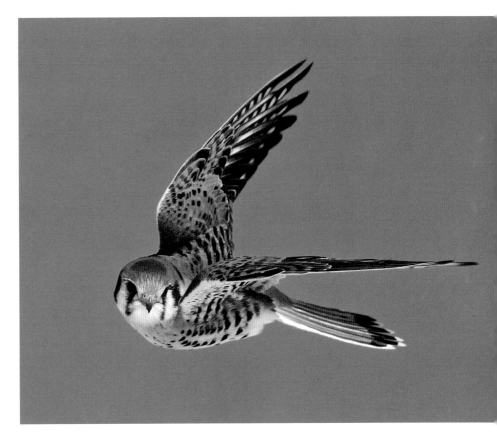

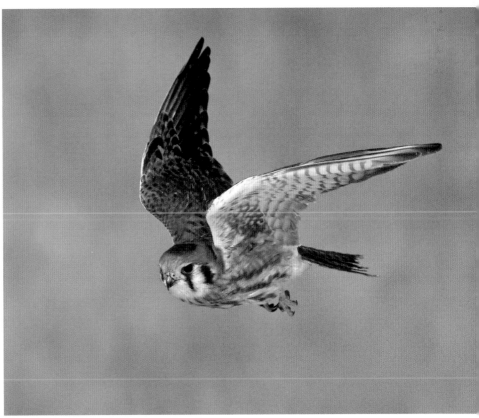

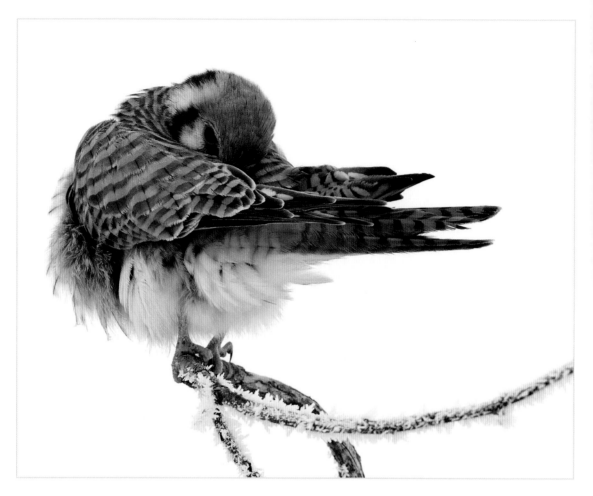

Winter

above—Winter is the best time to photograph kestrels, especially when there is snow on the ground. The snow reflects the light and really accentuates the beautiful plumage of both the male and the female.

right and facing page—Here are another two photographs to compare the difference between the male (right) and the female (facing page). Both birds were photographed on the same cold winter day in Colorado.

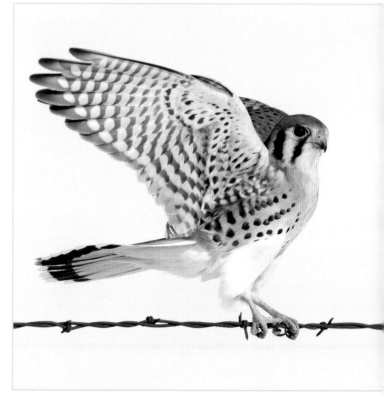

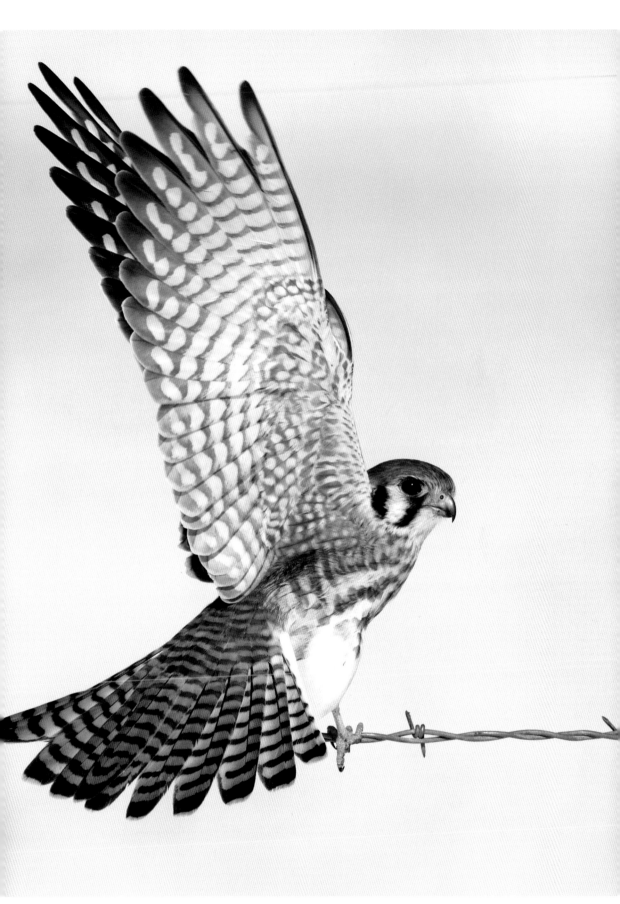

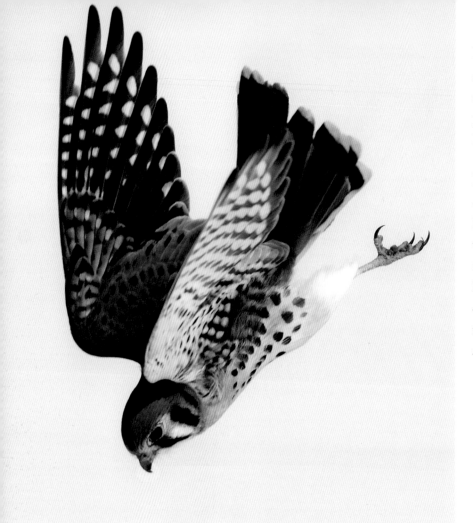

Diving

top left—A male kestrel diving down from his perch on a telephone line into the snow.

Hovering

bottom left—The kestrel had to slow down to try to find the mouse in the snow. He hovered about a foot off the ground, then finished his pounce and caught the mouse.

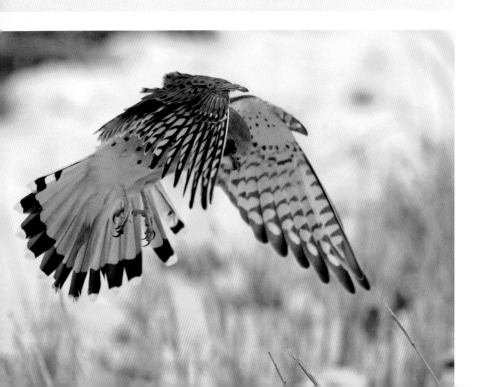

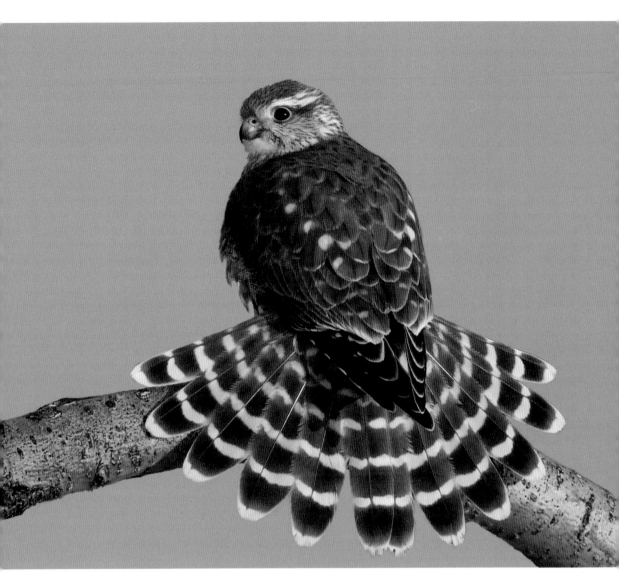

Merlins

above—The merlin is the second smallest of the falcon family in North America. Merlins are a little smaller than pigeons, but a lot faster. They are the turbocharged birds of the raptor family, thinking nothing of chasing down a small bird over a mile or two. Merlins are not as colorful as kestrels, but they are still beautiful birds.

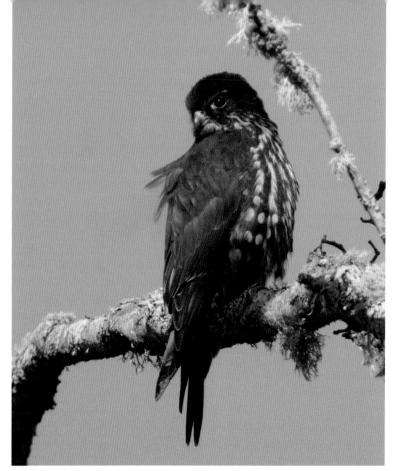

Subspecies

left, top and bottom—There are three distinct subspecies of merlins in North America: the prairie merlin (page 95), the black merlin (top left) and the tundra or taiga merlin (bottom left). I especially like black merlins, which are found in northwestern United States and western Canada.

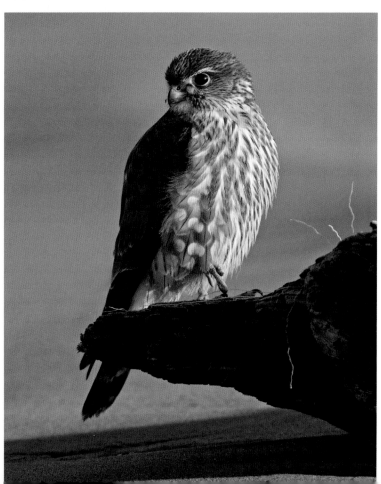

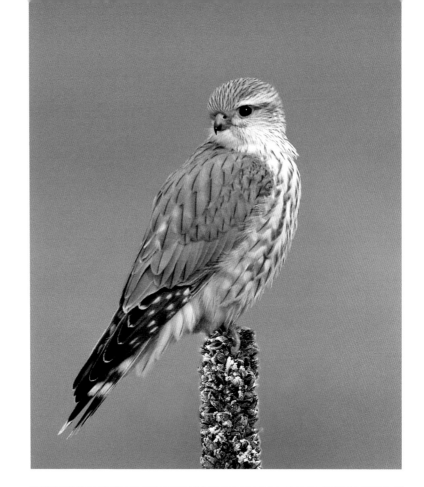

Weight

right, top and bottom—Where
I live, the prairie merlin
is most common. Merlins
typically weigh in at 5 to 8
ounces. The prairie merlin
is the largest of the three
subspecies—but not by much.
It tips the scale at about an
additional 10 grams (just .3
ounce). The merlin in the
top photo, with the beautiful
slate blue back, is an adult
male merlin, sometimes
called a "jack" merlin.

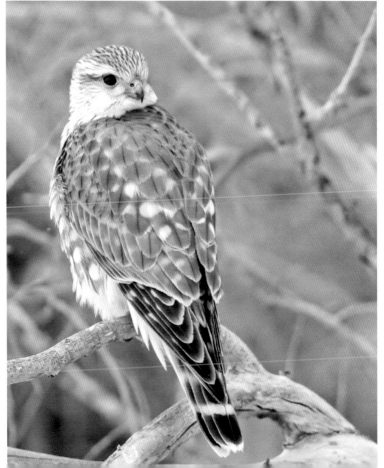

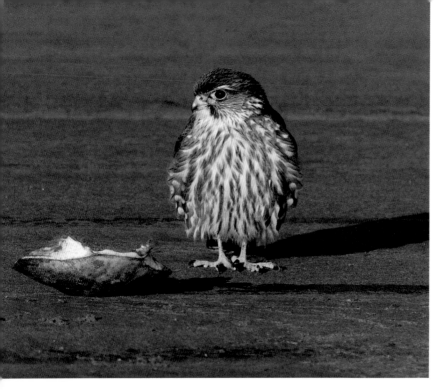

Habitats

left—A beautiful little merlin on the beach in western Washington.

below—This is a typical habitat for merlins in Colorado—sitting on a fence post, hiding a little from unsuspecting birds. Merlins mainly feed on small birds, from sparrow-size to pigeons, although they will pursue rodents and insects in the summer.

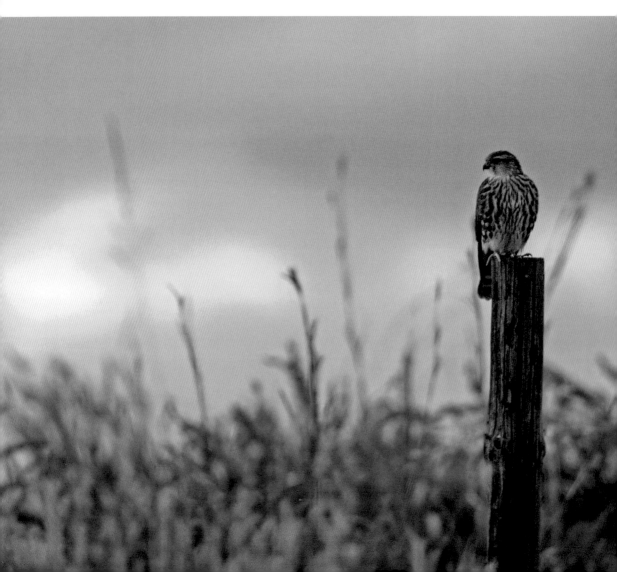

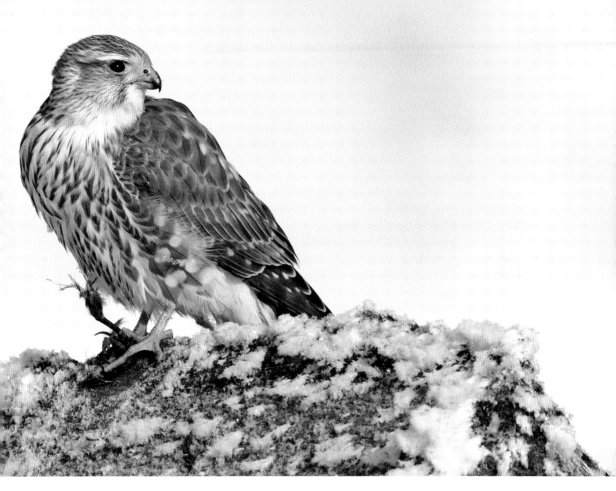

Snow

above—Here, a merlin is finishing a meal on a chilly winter morning in Colorado.

Stretching

right—This merlin was stretching just after a meal. This kind of double-wing stretch is called a "warble."

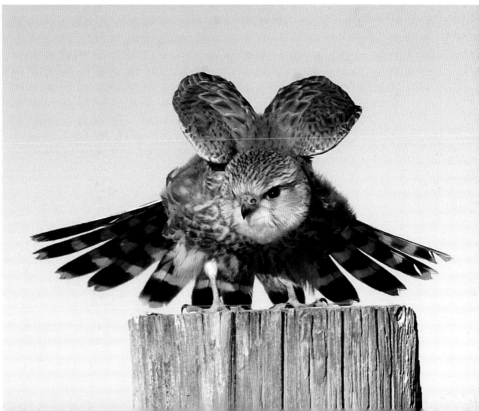

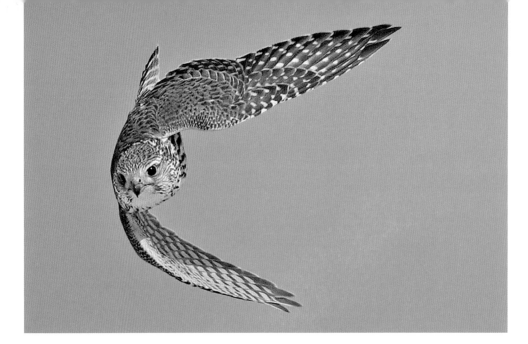

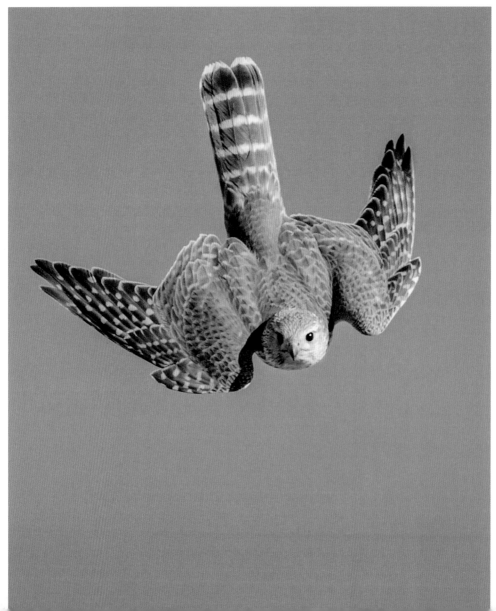

Little Bullets in the Air

facing page and right—Merlins chasing their prey look like little bullets as they speed through the air.

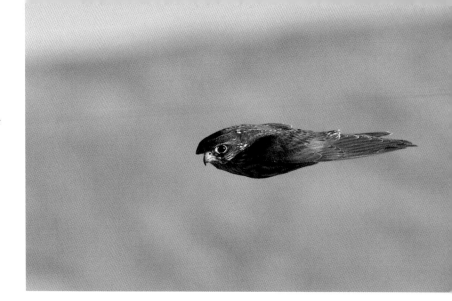

Dinner Time

below—Another male prairie merlin eating a sparrow. If you do get lucky enough to see one of these birds on a fence post or a tree, it is normally eating something. More often, however, you see them speeding by, chasing birds. They don't like to sit still very often.

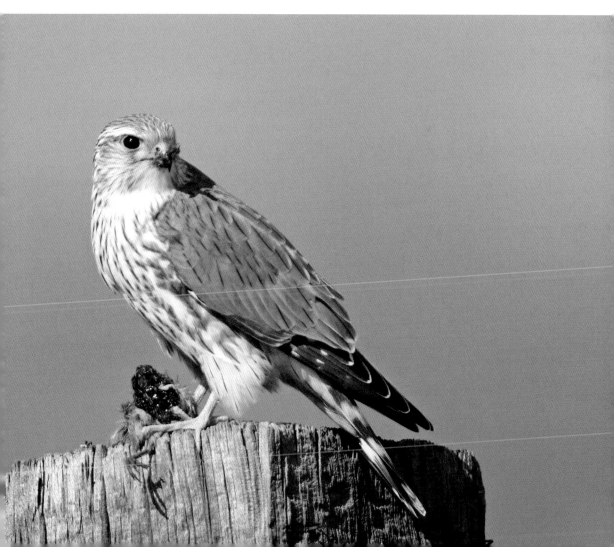

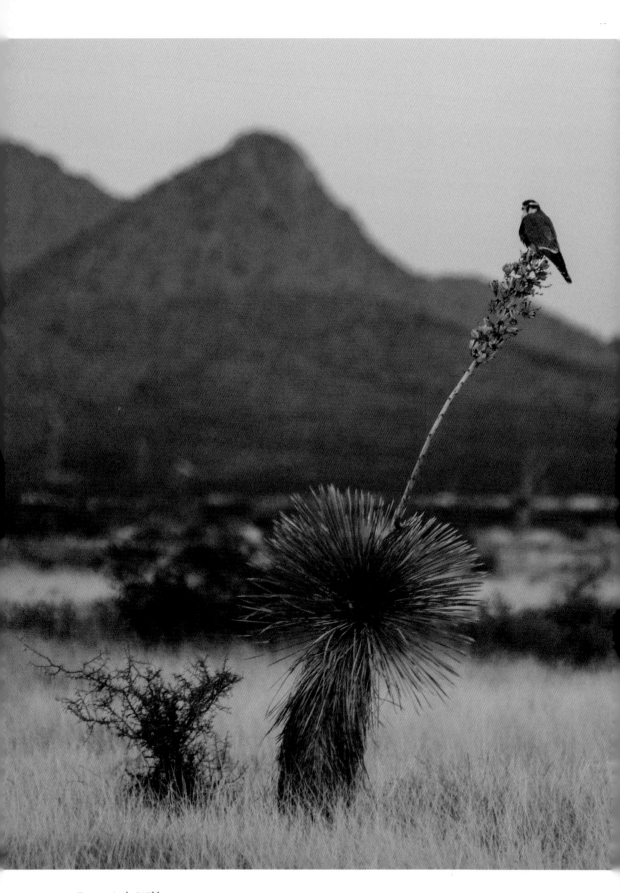

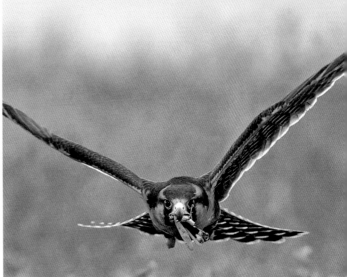

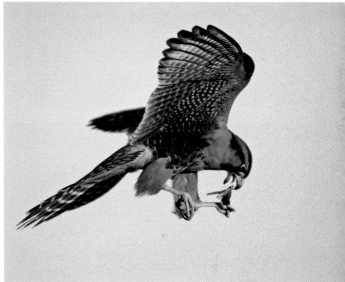

Aplomado Falcons

left—The aplomado falcon is a bird of the southwest, found in southern New Mexico, south Texas, and Mexico. It is considered to be endangered in the United States, but the worldwide population is in good shape.

above—During the summer and early fall, aplomado falcons like to catch flying insects like dragonflies and then graduate to the small birds that are usually found in the area. Just like merlins, aplomado falcons will pursue birds a long way before either catching the prey or giving up the chase.

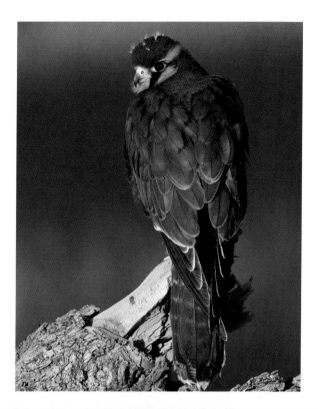

Age

left—Here is a just-fledged youngster on a tree stump. You can tell he's a youngster because of the downy feathers on top of his head.

below—The same bird, a little older and sitting on a juniper.

Coloration

facing page—The coloration and barring of the feathers of an aplomado falcon are stunning. In Spanish, the word "aplomado" means "resembling lead," an apt description of the blue-gray areas of this bird's plumage.

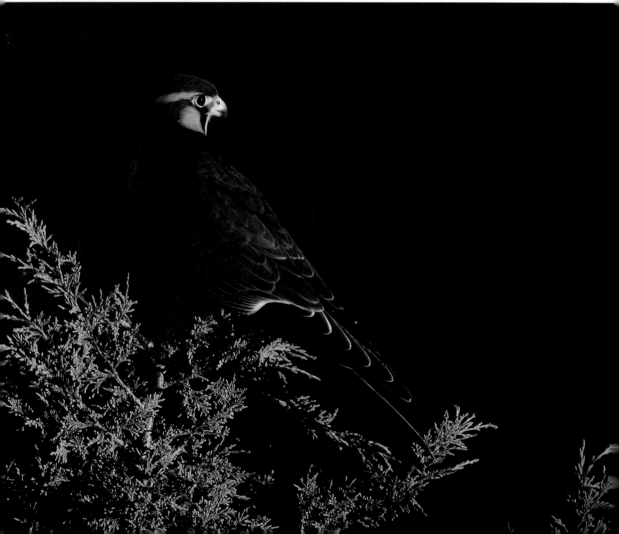

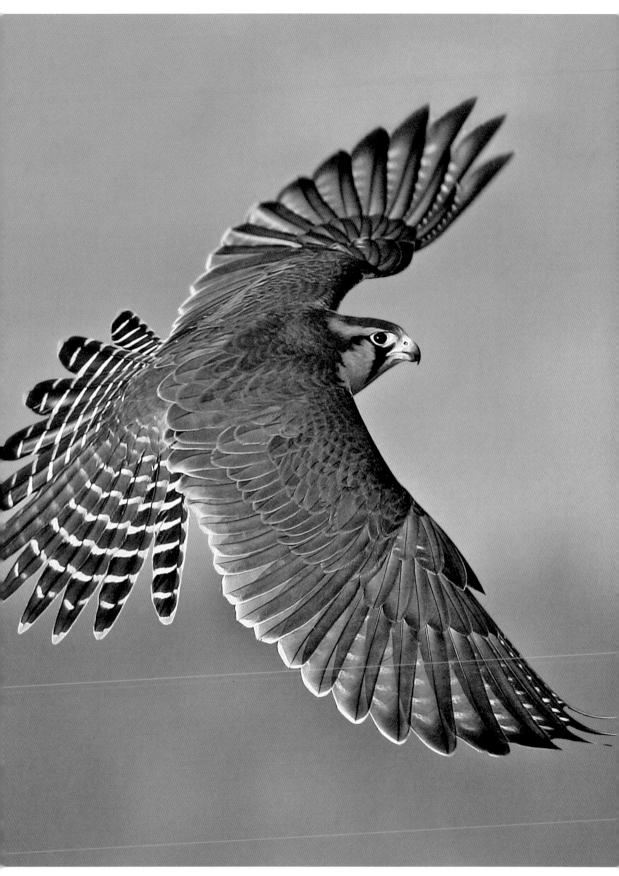

Peregrine Falcons

Peregrines are the iconic falcon species. Found all over the globe with various plumages, these birds are known to be the fastest of all animals. They have been recorded at speeds of over 220 miles per hour, and there is some evidence they can move even faster than that. It should be noted that this is not in level flight but in a dive or "stoop" (the term used for the downward swoop of a bird of prey) where they use the altitude of their location to fold their wings and dive vertically toward their prey. It is still a sight to behold—just don't blink your eyes.

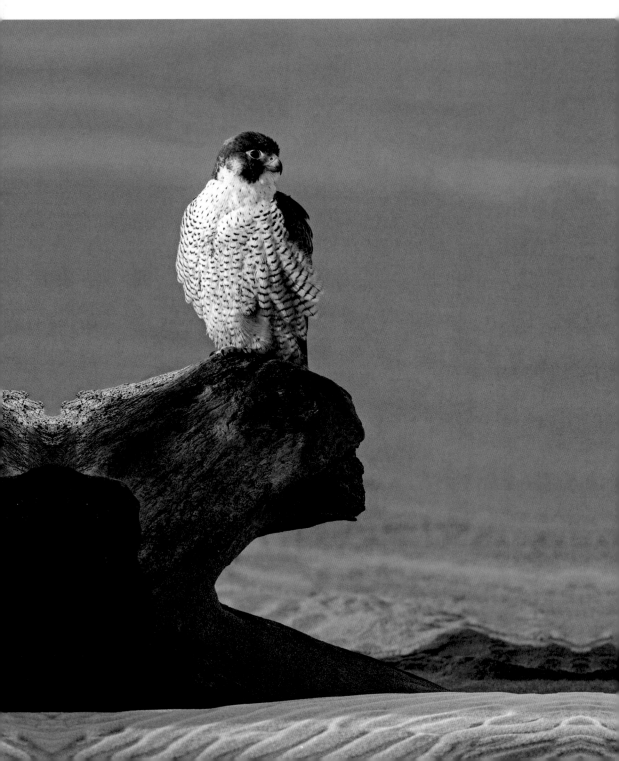

below and right—One of the best places to see these birds is on a beach. They like to hang out on driftwood, watching the shore birds, and start their attack from that location. When you see a flock of shore birds flying very close together all turning as one, there is a good possibility that they are under attack by a peregrine falcon.

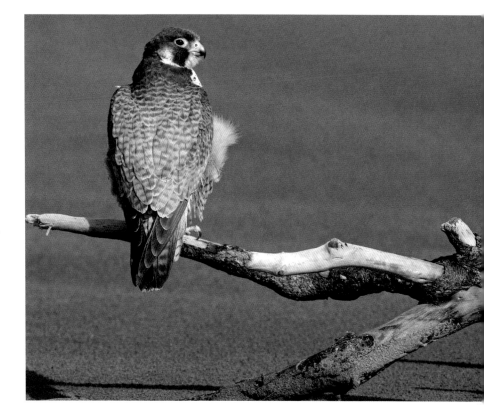

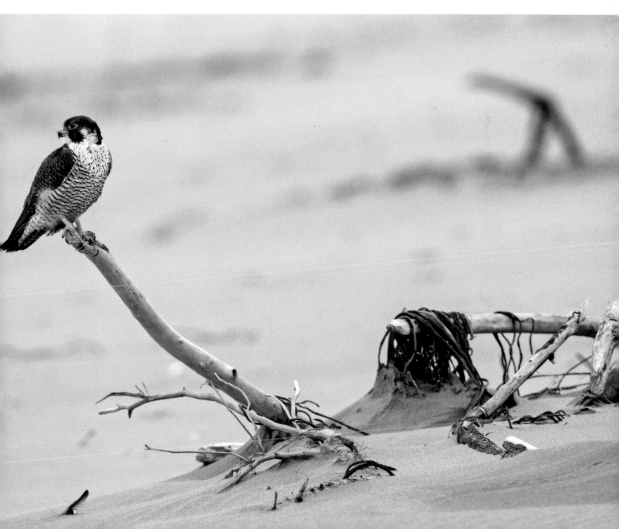

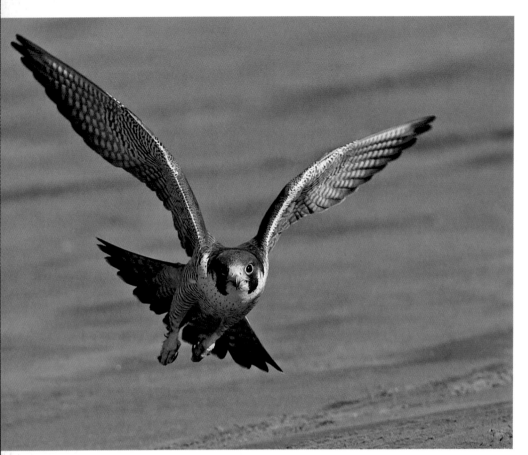

Hunting

left—An adult peregrine falcon in pursuit of a pigeon on the Washington coast.

below—This peregrine's hunt was successful; it caught the pigeon.

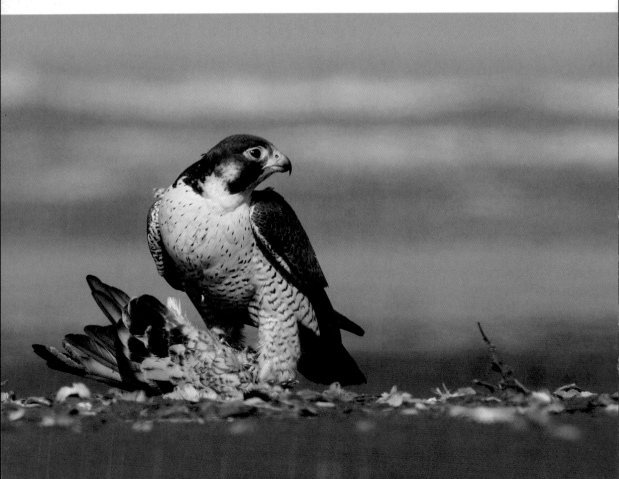

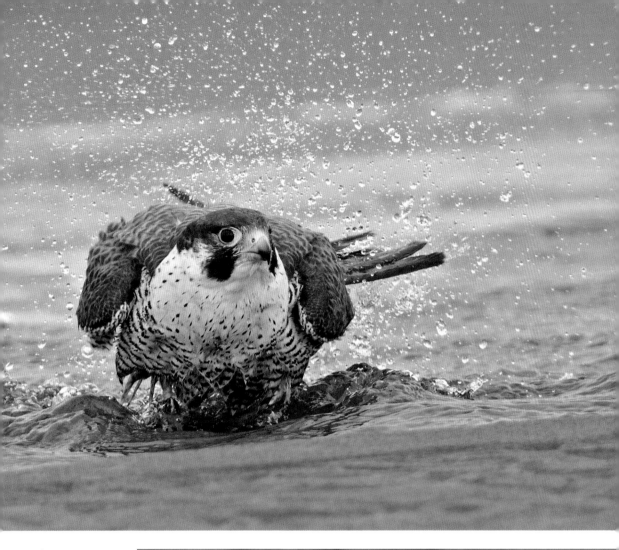

Bath Time

above and right—

After a strenuous chase, a peregrine falcon deserves a refreshing bath.

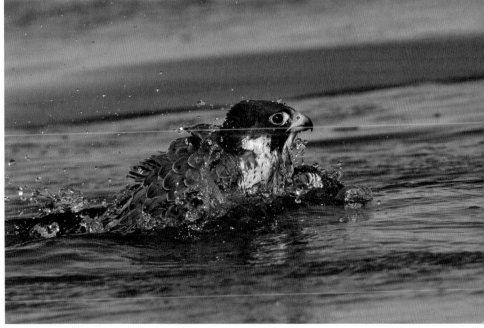

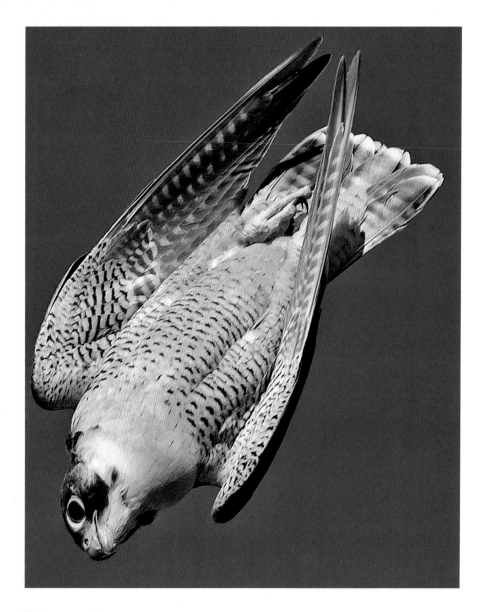

Dive

above—This peregrine was photographed in a dive (or "stoop"). Peregrine falcons can reach speeds of over 220 miles per hour in a dive.

Surveying the Terrain

facing page, top—A peregrine surveys the farmland for birds. This image was shot in Colorado, overlooking Long's Peak.

Falcon Portrait

facing page, bottom—A close-up portrait of a peregrine falcon.

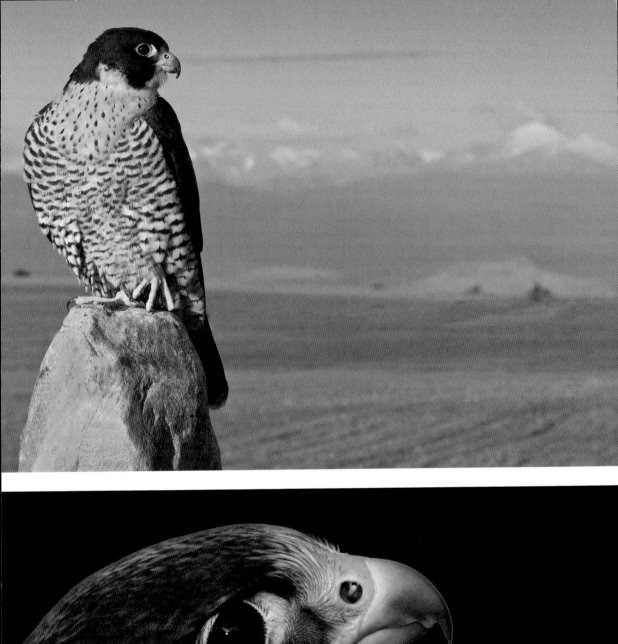
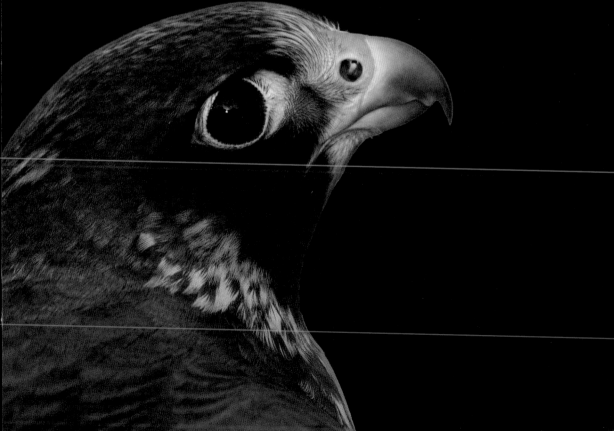

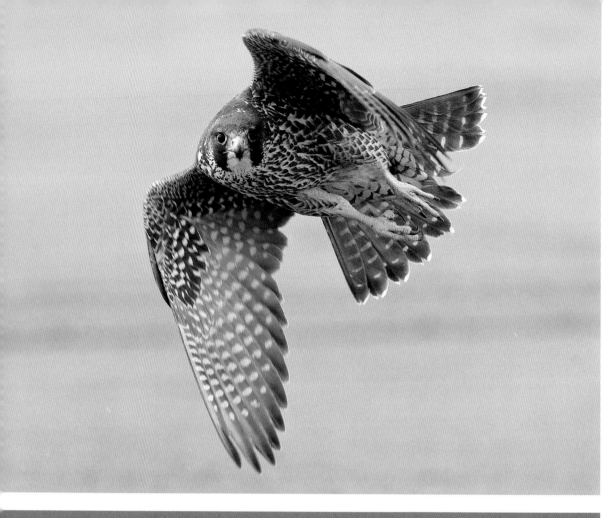
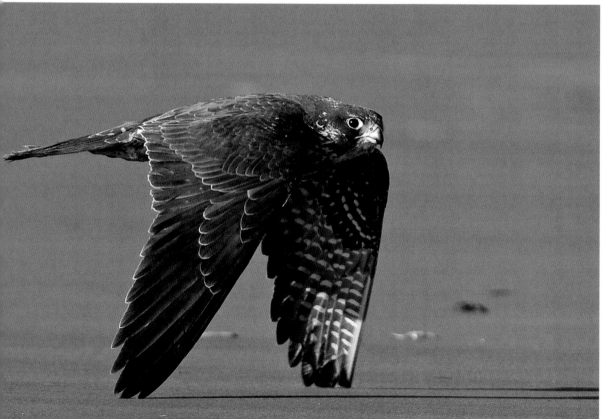

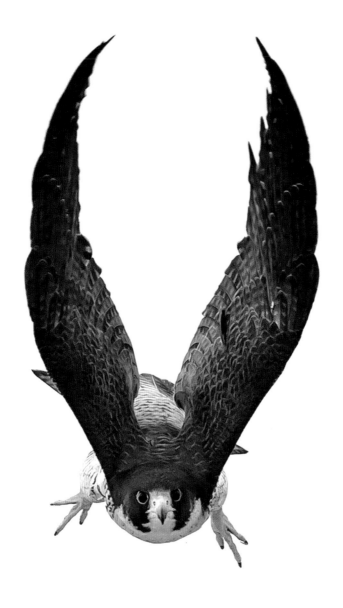

Head-On

above—A beautiful photo of an adult peregrine falcon flying right at the camera. *Photograph by Angela McCain.*

Immature

facing page, top—An immature peregrine on the beach in Washington.

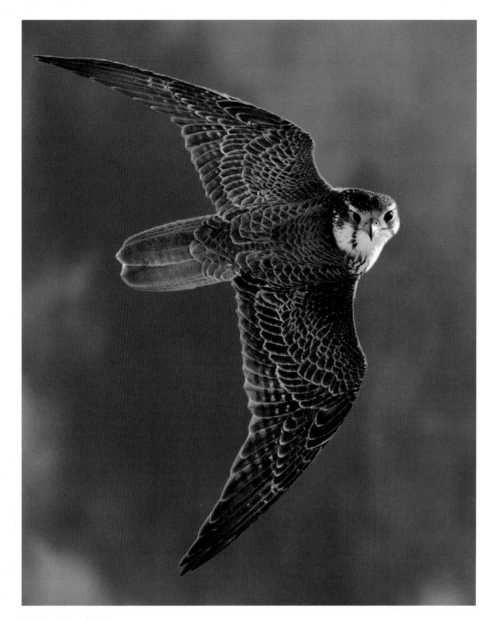

Prairie Falcons

above—Prairie falcons are the desert counterparts to peregrine falcons. They are nearly the same size but much lighter in coloration.

Nesting

facing page, top—As raptors that prefer the wide open plains and deserts, prairie falcons are the iconic birds of wildness. They nest on cliffs along rivers and mountains, placing their eggs directly on the surface of a scrape in the rocks.

facing page, bottom—This female is using an abandoned hawks' nest as a home for her offspring.

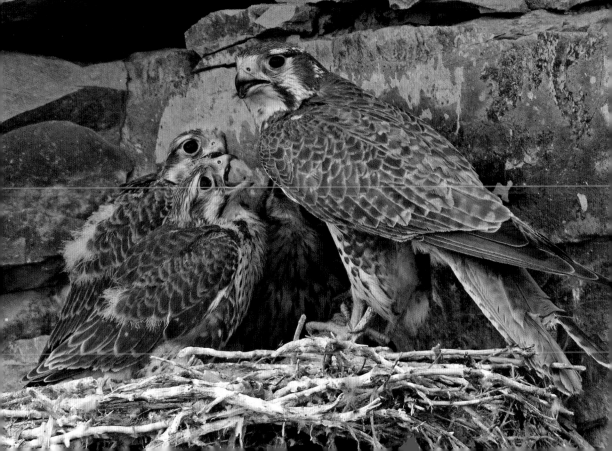

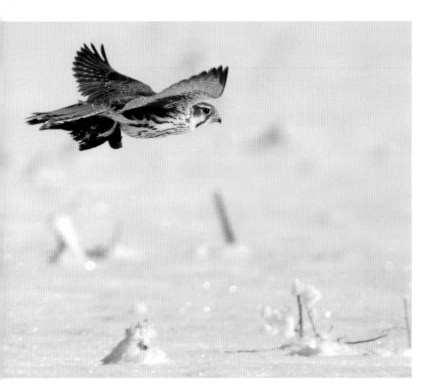

Starling for Dinner

left and below—This prairie falcon has a starling tucked away for future eating. Unlike peregrines, prairie falcons can tolerate very cold temperatures. Peregrine falcons migrate to warmer climates in the winters, but the prairie falcons stay in one general area all year.

facing page, top—This adult falcon was a little upset when I moved a bit too close to its nesting area.

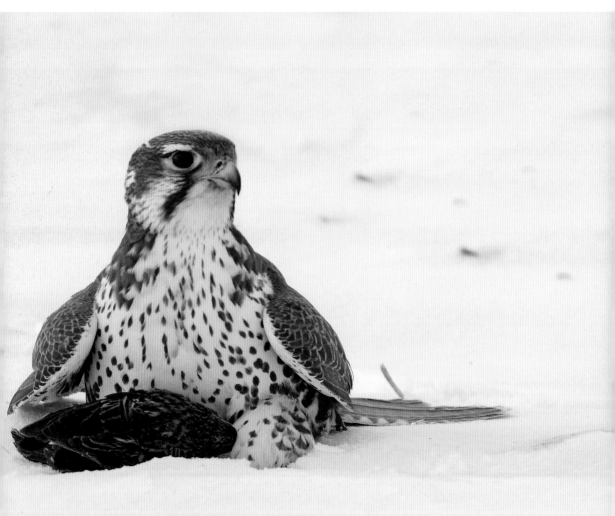

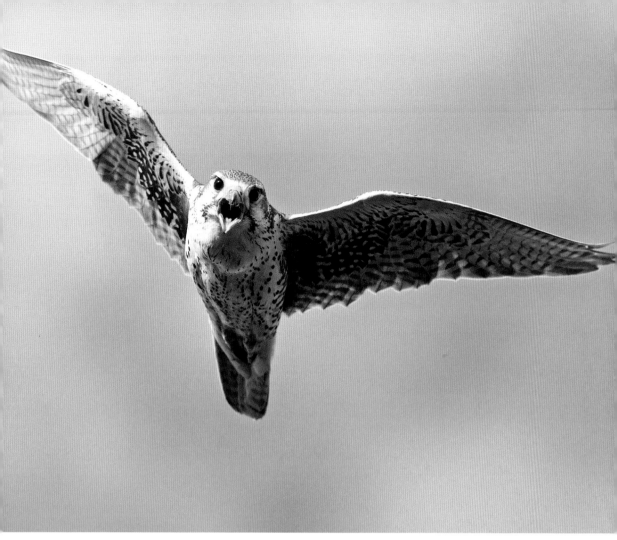

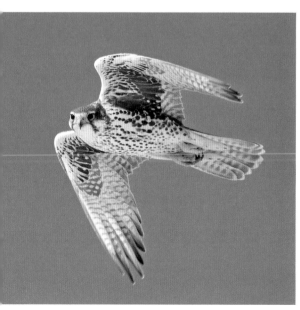

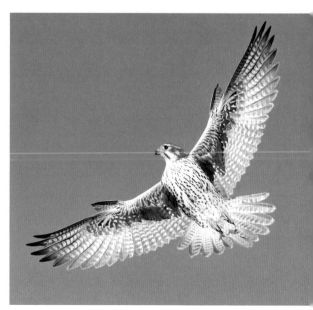

above—An adult falcon taking a look right at the camera.

above—This adult falcon is showing the dark feathers under its wings. These are used by birders to identify the fast-flying birds.

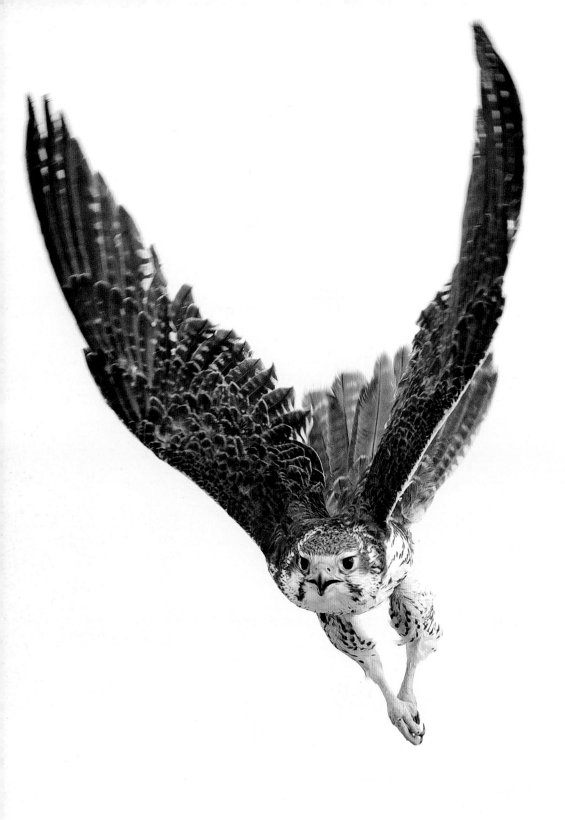

above—Incoming!

Gyrfalcons

Gyrfalcons are the largest of all the falcon species and the fastest in level flight. Reaching speeds of over 70 miles per hour, they can literally fly down any other animal in level flight. They are also very fast in a dive (stoop), but not as fast as the peregrine falcon.

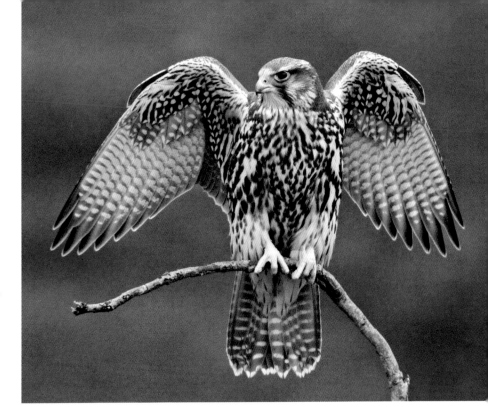

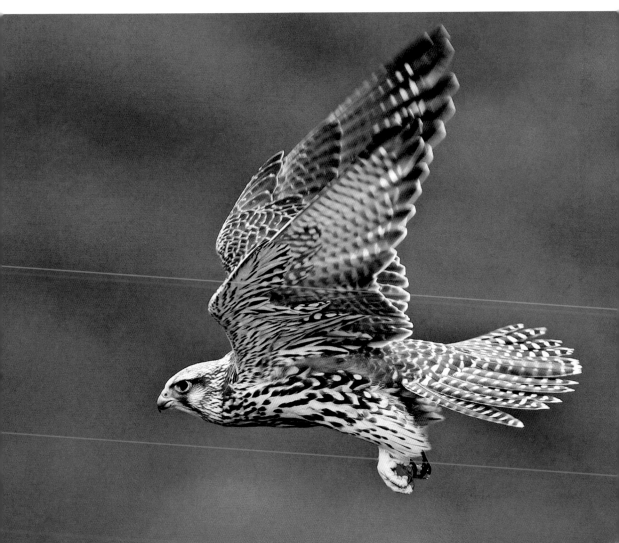

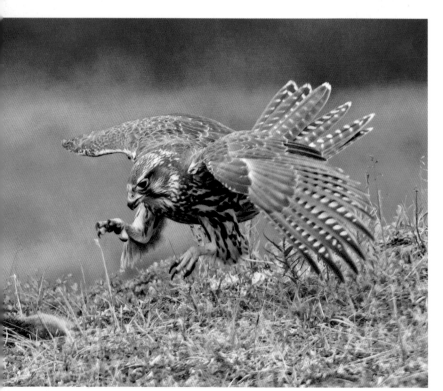

Practice Hunting

left—This young falcon is playing with his food—a meal brought in by a parent bird. Although the ground squirrel is dead, the young falcon still likes to do a mock battle and practice grabbing at the squirrel.

below—After the falcon eats the squirrel, it's time to relax on a small perch and wait for a parent to bring another.

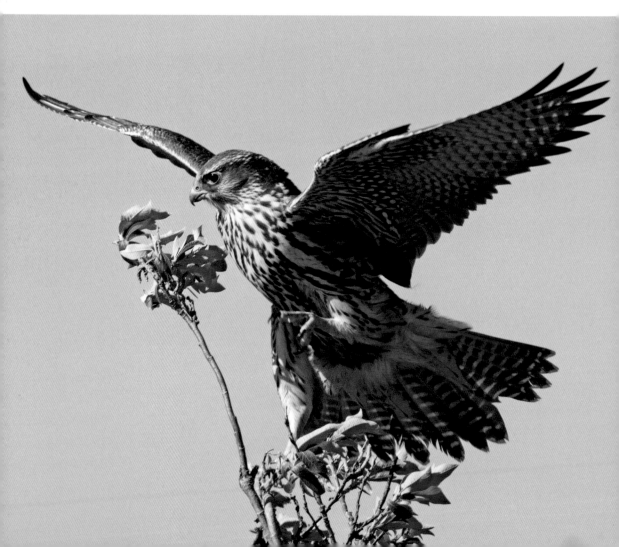

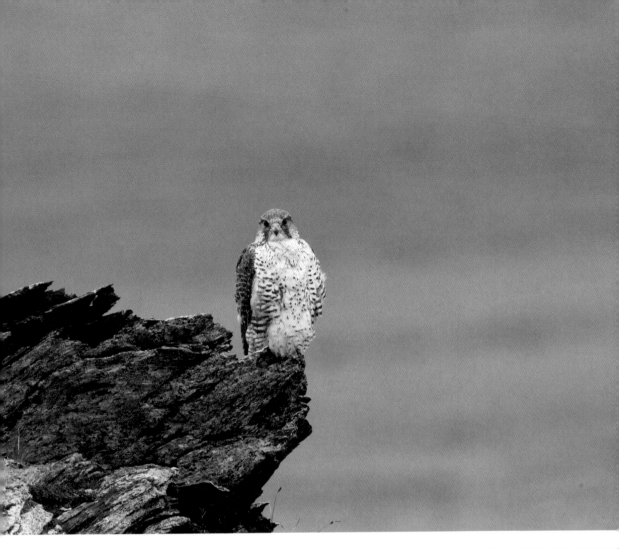

above—An adult falcon sits on a rocky outcropping, surveying for prey.

Coloration

right—Portrait of a beautiful white gyrfalcon. The gyrfalcon comes in various morphs: white, silver, black, and gray (the most common). The white bird is the most treasured of all birds for falconers and was considered to be the "King's Falcon" back in medieval times.

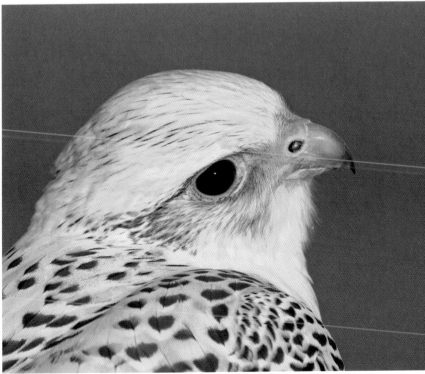

right—A magnificent adult white gyrfalcon.

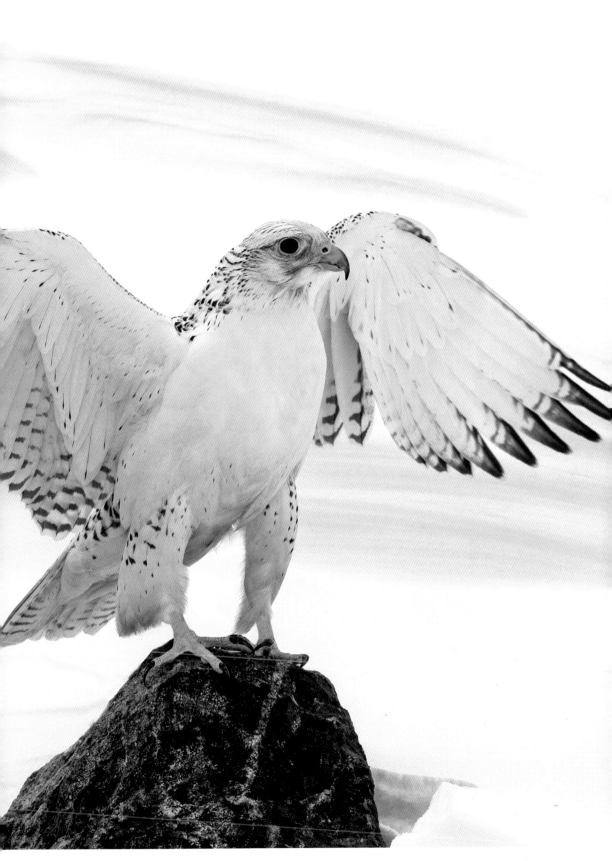

18. Personal Favorites

I'd like to close out the book by looking at two of my favorite images of raptors that I have taken over the years.

American Kestrel

This first photo shows an American kestrel hovering over a field while looking for a mouse. The reason I like this is because of the exaggerated motion in the wings compared to the steady head as the kestrel stays in one location, locked onto the prey beneath. In order to capture this photo I had to use a very slow shutter speed ($\frac{1}{40}$ second) to get the blur in the wings. I was elated when there was no blur in the head. To this day, it is one of my favorites.

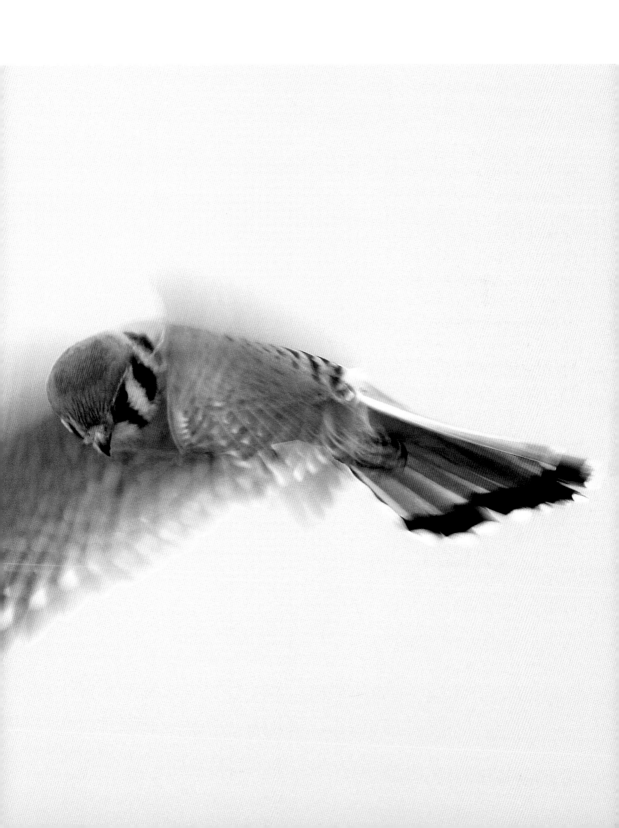

Bald Eagle

My other favorite is this one, showing a bald eagle about to catch a starling. This is a very uncommon event that I have only seen once in my lifetime. Starlings are very elusive birds and for an eagle to catch one in mid-air is no small feat. However, this starling was not feeling too well. I photographed this near a cattle feed lot in Colorado and the owner was using a pesticide to rid the area of starlings and blackbirds. I think toxin may have affected the nervous system of the starling, which flew straight up into the air without noticing that there was an eagle up there. The eagle flew straight at the starling and the smaller bird did not make any evasive moves. Eventually, the eagle did catch and eat the starling.

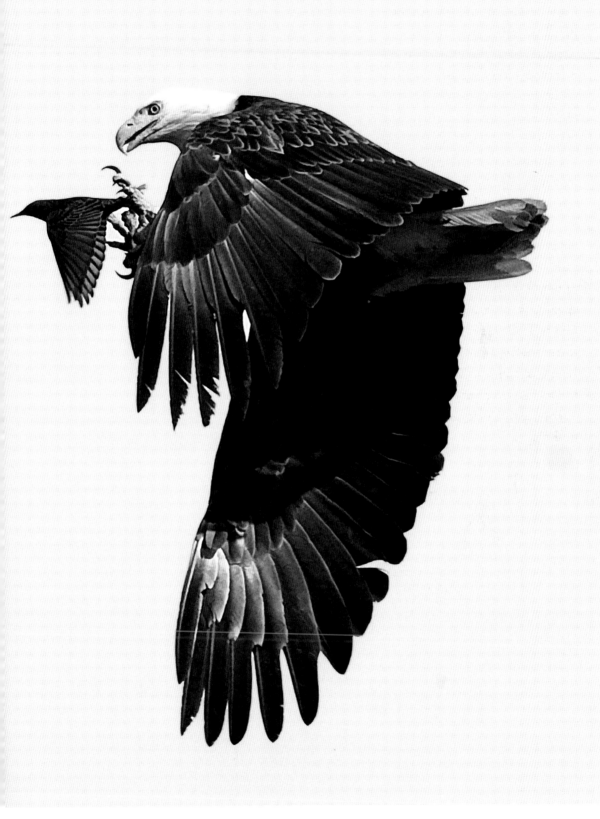

Index

Big Cats in the Wild

Joe McDonald's book teaches you everything you want to know about the habits and habitats of the world's most powerful and majestic big cats. *$24.95 list, 7x10, 128p, 220 color images, index, order no. 2172.*

The Complete Guide to Bird Photography

Jeffrey Rich shows you how to choose gear, get close, and capture the perfect moment. A must for bird lovers! *$29.95 list, 7x10, 128p, 294 color images, index, order no. 2090.*

Bushwhacking: Your Way to Great Landscape Photography

Spencer Morrissey presents his favorite images and the back-country techniques used to get them. *$37.95 list, 7x10, 128p, 180 color images, index, order no. 2111.*

Conservation Photography Handbook

Acclaimed photographer and environmental activist Boyd Norton shows how photos can save the world. *$37.95 list, 8.5x11, 128p, 230 color images, index, order no. 2080.*

Underwater Photography

Take an underwater journey with Larry Gates as he explores a hidden world and reveals the secrets behind some of his favorite photographs created there. *$37.95 list, 7x10, 128p, 220 color images, index, order no. 2116.*

Wildlife Photography

Joe Classen teaches you advanced techniques for tracking elusive images and capturing magical moments in the wild. *$34.95 list, 7.5x10, 128p, 200 color images, order no. 2066.*

Storm Chaser
A VISUAL TOUR OF SEVERE WEATHER

Photographer David Mayhew takes you on a breathtaking, up-close tour of extreme weather events. *$24.95 list, 7x10, 128p, 180 color images, index, order no. 2160.*

Digital Black & White Landscape Photography

Trek along with Gary Wagner through remote forests and urban jungles to design and print powerful images. *$34.95 list, 7.5x10, 128p, 180 color images, order no. 2062.*

Macrophotography

Biologist and accomplished photographer Dennis Quinn shows you how to create astonishing images of nature's smallest subjects. *$37.95 list, 7x10, 128p, 180 color images, index, order no. 2103.*

Magic Light and the Dynamic Landscape

Jeanine Leech helps you produce more engaging and beautiful images of the natural world. *$27.95 list, 7.5x10, 128p, 300 color images, order no. 2022.*